Critical Focus

Critical Focus

Photography
in the International
Image Community

by A. D. Coleman

Nazraeli Press

"There's more to the picture
than meets the eye ... "

Neil Young
Hey, Hey, My, My
(Out of the Blue,
Into the Black)

Contents

ART CENTER COLLEGE OF DESIGN

Introduction *by Bill Jay*

If an electrocardiogram were attached to the body of contemporary critical writing about photography, the signs of life would be meagre indeed. The screen would project the flat line of near-death, with only a few sharp peaks to indicate that there is the faintest hope of recovery.

Most of the highest and brightest peaks are being generated by the writings of A. D. Coleman.

Peaks can be defined only in contrast to the surrounding plains, so it is worth expending a few words on the dearth of fine critical writing in photography in order to see Coleman more clearly.

In the past couple of decades a new type of critic, and therefore a new type of critical writing, has dominated the medium. And, yes, I do mean "dominated," if the periodicals under review are restricted to those which purport to service the more serious, fine-art aspects of photography. This will come as no surprise to those of you reading these words. Because I am ever-anxious to appear judicious, tempered in my responses, surpassingly fair to the sensitivities of my colleagues and balanced in my appraisals, I will merely assert that the new-critic is an academic hack of minor attainment whose motivating force is self-aggrandizement through the regurgitation of shallow ideologies presented in graceless, tortured prose of utter incomprehensibility and sprinkled with irrelevant quotations from third-rate French philosophers.

As we are all aware, there is a predatory instinct in a small, but seemingly growing, segment of the public – the idea that things (money, possessions, power) should be entitlements, handed over without payment in hard work,

commitment to clear goals, the risk of failure or any investment in time and care. Muggers, for example.

The medium's periodicals which pretend to the more thoughtful band of the photographic spectrum are full of writings by individuals who do not work at the craft of criticism, but presume that the opportunity to express their prejudices and ideologies is an entitlement, not a hard-won responsibility.

Against this background, the achievements of A. D. Coleman stand out in sharp relief. Why? Just what is it about him that deserves your respect and attention, if not your agreement on every issue?

The succinct answer is that Coleman, in his writings as in his life, consistently displays a deeply felt photographic "conscience," a sense of the moral imperative, a conscious intent towards what is right and good. I write these words with some trepidation, in the knowledge they are apt to prompt the gagging reflex in the cynical and jaded, and in the awareness that A. D. himself might disavow such heady aspirations. Nevertheless, I am convinced this "conscience" is not only evident in all his works but also an essential prerequisite for all works of importance, irrespective of the medium or field. A reviewer of A. D. Coleman's first collection of essays was seemingly disturbed that "In terms of its literary genre, *Light Readings* approaches the personal journal . . . (it) is biographical." Precisely. The essays are suffused with a deeply felt life-attitude, and this awareness of authorship presumes a willingness to take moral stands on issues, which, in turn, demands a personal courage which is singularly lacking in others who might, indeed, find such a conscience intimidating.

These personal imperatives are not overt but implicit in the text, because Coleman is too busy in the proper business of the critic. W. H. Auden has defined the functions of the critic in such a succinct list (*The Dyer's Hand*, Random House, 1948) that it bears repeating. The critic, says Auden, "can do me one or more of the following services":

1. Introduce me to authors or works of which I was hitherto unaware.
2. Convince me that I have undervalued an author or a work because I had not read them carefully enough.

3. Show me relations between works of different ages and cultures which I could never have seen for myself because I do not know enough and never shall.
4. Give a "reading" of a work which increases my understanding of it.
5. Throw light upon the process of artistic "Making."
6. Throw light upon the relation of art to life, to science, economics, ethics, religion, etc.

I would challenge anyone to name another critic in the medium of photography who fulfills as many of Auden's functions as A.D. Coleman.

There is an interesting reason for this uniqueness: Coleman's beginnings were in the areas of play-writing, fiction, poetry and music. Although he is now a full-time professional critic, some of these talents are still avocations and remain the literary background of his observations on photography. Most fine critics of the past were primarily photographers who espoused and advocated particular and personal rationales for their image-making. Although these observations were often astute and convincing, of necessity they were narrow of focus.

Not since the Photo-Secession has a critic emerged from outside the ranks of photographers who has committed himself with such verve to the medium of photography – and brought to his writings the benefits and insights of a broad literary perspective.

Since 1968 Coleman has breathed fresh air into the otherwise moribund corpse of photography criticism and almost single-handedly kept its spirits alive.

Trust me. Read him.

Preface

My critical project, initiated in 1968, began as and remains an attempt to provoke and participate in an ongoing society-wide debate over visual communication via lens imagery and its manifold consequences.

Such an agenda requires a regular forum in a large-circulation publication that is distributed to a sizeable general audience at low cost. Along with Walter Benjamin, I believe that ". . . the place where the word is most debased – that is to say, the newspaper – becomes the very place where a rescue operation can be mounted. . . . [T]he newspaper is, technically speaking, the writer's most important strategic position."*

Subsequent to my forced departure from the pages of the *Village Voice* and the *New York Times* in the early 1970s, I found myself for many years unable to gain access to such a forum. Instead, I became unwillingly ghettoized in art and photography periodicals, with occasional book opportunities. While I was delighted to be able to reach the readership of a variety of small and hard-to-find magazines and journals (*Exposure, Camera 35, Lens' On Campus* and *Artforum* among them), I was frustrated at being restricted to those specialized audiences because, as Alfred North Whitehead once said, "I write for the layman." I'm convinced that some of whatever impact my writing has had is attributable to its viability in mass-circulation presentational contexts. So my search for vehicles through which my writing could be made available to the general public continued.

Then, in the late summer of 1988, with the encouragement of then-Culture Editor Suzanne Mantell, I created a slot for myself at the *New York Observer*, a new weekly newspaper, and began producing a weekly

column on current photography-related books and shows. At that juncture I was also providing criticism, commentary and reportage to some publications abroad, *European Photography* foremost among them. Henry Brimmer of the San Francisco-based magazine *Photo Metro* got wind of all that, and my goose was cooked. Somewhere along the line, over beers, he said something like this: "Listen, Allan. Suppose you just take whatever you're writing for these other publications that you think would be interesting for *Photo Metro* readers, package it into a column, and send it out to us once a month with some pictures? You'll get a west coast readership; they'll get input and opinion about work and events from outside the region and even outside the country."

Though the idea hadn't occurred to me, this proposition did not take me entirely by surprise; Henry and his magazine and I already went back a ways, and the desire to collaborate was mutual. So, when he proposed that basis for a column, how could I say no? By then I'd been working for a couple of years on an IBM-PC, which makes such re-editing comparatively simple. Besides which, I've got a soft spot in my heart for the Bay Area, where I spent the best of the Sixties going to graduate school, playing rock and roll and radically altering my consciousness. So I agreed. Shortly after New Year's Day in 1989, I sent in the kickoff piece in this series I'd decided to call "Letter from," and we were underway.

That first "Letter from" appeared in the March 1989 issue. There have been some sixty since. Aside from the New York scene, they've by now covered local and national events in Rockport, Philadelphia, Rochester, Washington, D.C., Las Vegas, Houston, San Francisco, Santa Monica – and, outside the US, in the Czech Republic, France, Germany, Israel, the Netherlands, Scandinavia, Spain, and Switzerland. This book draws on the first forty-seven of those articles, skimming off much of the cream of the column's first five years. A few of the columns are presented in their entirety; with rare exceptions, the excerpts from other columns appear here, as they did there, as complete, self-contained segments. The reports on photo festivals have been trimmed for reasons of space. All excisions from a given essay I've indicated with ellipses. Some minor corrections aside, none of these pieces have been revised.

Much of this material – the book and exhibition reviews, primarily – first appeared in the *New York Observer* and *Photography in New York*. But, because the forum is right for it, and because I believe in giving good weight, a number of these pieces (principally the reports on festivals and overseas events) were written, either in whole or in part, especially for *Photo Metro*.

The period during which I produced the body of work that was distilled in my first published volume of occasional pieces – *Light Readings: A Photography Critic's Writings, 1968–1978* (1979) – witnessed an explosion of the photo scene on a national level in the United States. The point at which I began reviewing and reporting regularly again – coincidentally, almost exactly twenty years after my first essay on photography appeared – was one in which a parallel burst of activity was taking place on a global scale. This signalled the emergence of what I came to call the *International Image Community*, a microcosm with all the problems, pitfalls and potentials of the nascent European Economic Community.

By the early 1980s I'd become painfully aware of how geographically and culturally restricted my own view of photography – and the views of most of my colleagues in the US – must have seemed to anyone from outside our borders. The problem wasn't jingoism, nor even a willful parochialism, on anyone's part – just ignorance and lack of easy access to information. To rectify that deficiency in my own case, as well as to help my readers overcome it, I began making an increasingly concerted effort to broaden my own horizons, so that my understandings and commentary might take on a more expansive perspective.

Fortunately, my professional opportunities over the past decade supported that purpose in diverse ways, enabling me to nose around in that new territory at some length. The reader can determine whether I've succeeded or failed in that larger effort to internationalize my own overview of the field. Regardless of that – and my own hopes, fears, reservations, gratifications and disappointments in the evolution to date of that "international image community" notwithstanding – it's been profoundly instructive, indeed transformative, to function as both an observer of and an active participant in this photography-oriented version of McLuhan's "global village," as it invents itself at century's end. In addition to synopsizing

my responses to a wide range of contemporary photography and photography-related work, this book attempts to convey some of the excitement of engaging with that polycultural process, and to distill some essences of the lessons learned.

A. D. Coleman
Staten Island, New York
December 1994

* Benjamin, Walter, "Author as Producer," in *Thinking Photography*, edited by Victor Burgin (London: The MacMillan Press, Ltd.), p. 20. Today I would add, as a logical extension of Benjamin's concept, radio, television, E-mail and other electronic forms.

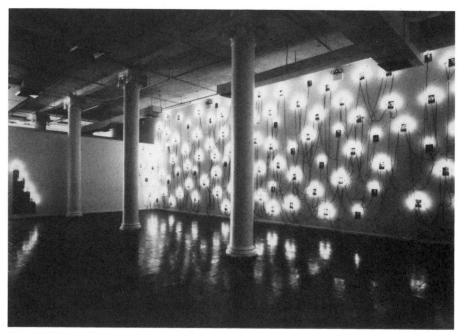

Christian Boltanski: *Monument: Les Enfants de Dijon*, 1986
Courtesy The New Museum of Contemporary Art

Letter from

Letter from: New York, No. 1

Is Christian Boltanski a photographer? Is the work he produces photography? In a literal sense, the answer to both questions must be negative. Yet photography – by which I mean not only photographs but also certain ideas inherent in the medium – is so integral to Boltanski's works that there's no way of discussing them without taking their photographic component into consideration as physical aspects of the stuff he produces and as philosophical referents.

Boltanski's pieces can be described best, if loosely, as installations; they're complex groupings of objects that, not unlike sculptures, alter the spaces in which they're presented. As revealed by the New Museum of Contemporary Art's retrospective, "Lessons of Darkness," many of them involve various kinds of "found" imagery (mostly black & white pictures of unnamed people) which Boltanski rephotographs. Sometimes these replications are out of focus, so that their subjects – who were specific, if anonymous – become generalized and archetypal.

From these and other simple components such as old tin boxes and drawers, clamp-on lights and electrical cord, Boltanski constructs environments in which the faces of large numbers of unknown people look out at the viewer, pregnant with unarticulated history. Early pieces like "The 62 Members of the Mickey Mouse Club in 1955" and "Photo Album of the Family D. Between 1939 and 1964" address in broad terms the question of individual versus collective identity. Both are wall pieces; they utilize symmetrical grids of identically-sized metal-framed photos. Whether their stated premises are true – that is, whether we are in fact looking at five

dozen Mouseketeers or members of a real family – is impossible to determine, but hardly moot; part of what's fascinating about Boltanski's work is its disclosure of just how desperately we want to believe that photographs actually show us what they claim to represent.

Biography and autobiography are also, perhaps inevitably, central themes here. Some of the works concern Boltanski's own life; "The Archives," for example, is a small room filled with row upon row of portraits – Boltanski's among them – crowded so closely that one can barely make them out. The sensation is rather like suddenly finding oneself surrounded by the dead files of someone else's memory. "Monuments" and "Altars," by contrast, are spaciously presented, yet no less elegiac in tone.

All of these issues come to a head in the most recent works, the "Lycées Chases" series, based on the 1931 graduating-class photograph of a Jewish school in Vienna. Enlarged, out of focus, and surmounted by clamp-on lights whose shades and bulbs are poised barely an inch away from the faces, individual portraits (alone or in small groupings) sit atop stacks of closed tin boxes reported to contain other material. Something unnamed but monstrous is almost palpable in the air; the room feels like a crypt. What happened to these children? Boltanski lets us imagine – and leads us to ask: What happened to all the children, including ourselves?

Letter from: New York, No. 2

Late-night talk show host David Letterman has made a significant contribution to media criticism with the curious invention he has dubbed "MonkeyCam." This involves strapping a small television camera to a member of one of the lower primate species, who is then set free in the studio during the taping of the show. Periodically, at Letterman's signal, the folks at the control board switch to "MonkeyCam," and there you have it: startling, vertiginously odd-angled glimpses from the monkey's vantage point.

Garry Winogrand (1928–1984) was nothing more nor less than still photography's version of "MonkeyCam": a restless, anxious primate with camera attached, constantly scanning – unaware of, unresponsible for and uninterested in the results.

The major traveling Winogrand retrospective organized by the Museum of Modern Art – "Garry Winogrand: Figments from the Real World" – has just passed through San Francisco, and will shortly be heading for Los Angeles. This extravaganza, along with its accompanying monograph, forces critics and observers of the medium to confront the corruption of meaningful discourse about photography, of which Winogrand's proposed ascension to the pantheon is emblematic.

Garry Winogrand once described his approach to photography in these words: "You see something happening, and you bang away at it. Either you get what you saw or you get something else – and whichever is better you print." No credo could be more self-indulgent or uncritical, especially since statistical probability is on the side of the small-camera photographer who "bangs away at it."

John Szarkowski has proclaimed Winogrand to be "the central photographer of his generation." He has yet to reconcile that assertion with his admission (in the texts which serve as wall labels for the show and which are elaborated further in the exhibit's lavish accompanying monograph) that Winogrand had no large idea, and that the work became redundant, collapsing in on itself toward the end. Indeed, the curator goes so far as to confess that the last seven years of Winogrand's work – including roughly a third of a million negatives Winogrand never even bothered to develop and/or contact-print – was a pointless waste.

This must be especially painful to Szarkowski. He and Winogrand were not only friends but teammates – Winogrand exemplifying the praxis, Szarkowski providing the theory. Furthermore, in his relation to post-World War Two photography Szarkowski's reputation as a curator will (by his own decision) eventually stand or fall on his decades of sponsorial commitment to Winogrand, and he's clearly on shaky ground. (Winogrand has been a veritable house brand at the Modern ever since Szarkowski's public backing of him began with the 1967 "New Documents" exhibit.)

For another thing, his argument that Winogrand's work embodies an expansive approach to the medium is belied by the work's petering out in such ineffectual self-imitation. Szarkowski himself calls the later work "deeply flawed." The "heroic" efforts to preserve Winogrand's last, "unedited" work become, in retrospect, an embarrassment. (Those three hundred thousand-plus negatives were developed and contact-printed by courtesy of a much-publicized grant from Springs Mills.)

The real problem here is that Winogrand's devotees and acolytes would have us see him as an epic poet. Unfortunately for them, his praxis – along with the theory that has sprung up around it, drafted by such photographer-critics as Ben Lifson, Leo Rubinfien, Tod Papageorge, and of course Szarkowski himself – is premised on what photographer-theorist Richard Kirstel has called "reverence for the intensity of the glimpse." And, in the last analysis, the glimpse is simply an insufficient basis for the construction of an epic vision. It will do for lyric poetry, for a Kertész, a Doisneau, a Levitt. But only Robert Frank ever built an epic on glimpses – and he managed that not by glimpsing better than other photographers, but by developing and

Letter from

maintaining a political stance and by painstakingly redacting his imagery into a spare, taut, book-length sequence (both of which commitments Winogrand studiously avoided).

Epic scale demands, among other things, the capacity for prolonged attention that Winogrand so clearly lacked. How seriously can we take the droppings of a gluttonous voyeur who spent the last seven years of his life producing a third of a million negatives without bothering to look at any of them, much less analyze them critically? This was not a photographer; this was a shooter, afflicted with a textbook case of terminal distraction, the quintessence if not the prototype of the dreaded "Hand With Five Fingers" you have surely seen in Nikon camera ads on TV.

At some time in the future, Winogrand's main usefulness to the medium will be seen to have been his willingness to go down this dead-end path and explore it to the bitter end – so that no one needs to pass that way again.

Letter from: New York, No. 4

In a poem about my own adolescence, I once wrote, "I never was a happy child, nor ever knew one." The same was certainly true of Diane Arbus – and, I suspect, holds for the painter Alice Neel. At least that's what's suggested by the evidence in a most unusual show, titled "Children," in which the work of those two is paired.

Guest-curated by John Cheim at the Robert Miller Gallery, this exhibit was initially planned to include the work of Cindy Sherman, who considers Arbus and Neel to be "role models." But Sherman bowed out at the last minute (on the amusing pretext of "fearing a risk of over-exposure," according to a press release from Cheim). It's hard to imagine what comparison Cheim had in mind among the three, but the parallels he draws between Arbus and Neel are immediate and striking.

Both are concerned with psychological portraiture – a form that, inevitably, involves self-portraiture, as it requires intuitive identification with the subject. They share a vision of children as hapless adults trapped in undersized bodies; they consistently portray the young as awkward, gawky beings with oversized heads, either frightened or inappropriately self-confident, fitted to the clothing and manners of adulthood as to some Procrustean bed.

There is no trace of the maternal here. Neither artist appears to have any fondness for babies, and Arbus seems to have been particularly terrified by them; in her images they are at best pathetic creatures, at worst monstrous ones. Nor is there anything endearing about their somewhat older subjects, any and all of whom could be part of a chorus chanting Pat Benatar's refrain, "Hell is for children."

Cheim does not try to establish any picture-to-picture relationships, nor even to suggest any direct influence in either direction. (That's a question worth further exploration, it seems to me; Arbus's work was, at the time of her death, roughly coeval with Neel's.) Each artist is represented by a group of 18 images, mounted in separate rooms rather than interspersed. Most of the Arbus images are familiar, but a few were new to this viewer, including "Penelope Tree in her living room," 1963; "Girl in a Watchcap," 1965; and "Susan Sontag with her son David," from the same year, made in Central Park.

Recontextualized in this fashion, however, even well-known images took on new resonance. Arbus's chilling "Boy with Hand Grenade," for example, contrasts powerfully with Neel's "Don Perlis and Jonathan," 1982, a particularly ghastly image in which the terrified child, rendered in a spidery scribble, seems like a wraith about to be absorbed by his more powerful father. "The Family," 1970 (John Gruen with wife and daughter) shows an emaciated daughter being virtually squeezed off the couch by her parents; "Antonia," 1982, gives us a pre-pubescent girl dressed like an old maid.

This exhibit pushes the viewer to reconsider the work of each of these two artists in the light of the other's. In doing so, it tells us something about women who were in some way in the vanguard in the post-war period, suggesting that part of their accomplishment was to break free of the assumption that they were genetically and/or socially obligated to view childhood as an idyllic passage and to feel maternal and nurturing themselves.

Finally, by treating a photographer as an artist whose work bears comparison to that of another artist who works with paint, curator John Cheim exemplifies an emerging breed of curators who take photography no less seriously than any other medium. For that, in and of itself, he deserves congratulations.

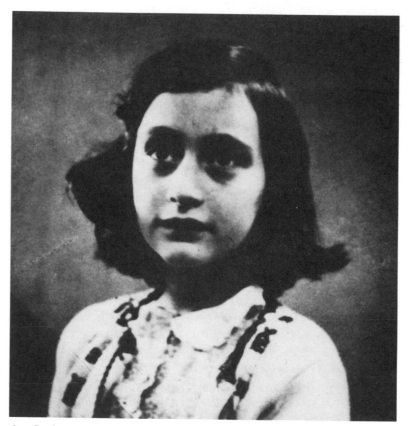

Anne Frank, 1939
© AFF/AFS Amsterdam

Letter from

Letter from: Jerusalem/Tel Aviv/New York, No. 5

It seemed appropriate to return to New York from a teaching stint in Israel just in time for Anne Frank Week. As I write this, Anne Frank would be turning 60 had she lived. Instead, she died in 1945 of typhus as a teenager in Bergen-Belsen, survived among her immediate family only by her father Otto. He edited and saw through publication the first version of her diary. Discarded by the Nazis on the morning the Franks were arrested, the diary – rescued by friends and returned to Mr. Frank after the war – became the first internationally-celebrated eyewitness account of the Holocaust almost immediately upon its publication in 1947. Its eloquent testimony to the human cost of fascism and anti-Semitism has done as much to keep neo-Nazism throughout the world on the defensive as any other single document.

Otto Frank, who died in 1980, bequeathed the handwritten diaries to the Dutch State Institute for War Documentation. Now a new, "critical" edition of *The Diary of Anne Frank* has been published by Doubleday. Amply annotated, it compares her first and second versions of many passages, analyzes her handwriting, even discusses the paper and ink with which she wrote. This may seem excessive scholarship to apply to a teenager's journal, but literary analysis is only part of the motive. The other is to lay to rest neo-Nazi claims that the diary is a forgery.

Given the fact that, in the face of all the evidence, there are some who contend the Holocaust never happened, such authentication is apparently necessary. For someone like myself, convinced that this horror took place, the controversy over the book – in any and all of its editions – has another meaning. The mountainous, overwhelming documentation of the Holocaust

is hardly ambiguous; furthermore, most of it is in effect confessional, produced as it was by the Nazis themselves. The compulsion to impeach it speaks to the trauma involved in acknowledging those impulses – and their logical consequences – in oneself and others. If the Holocaust itself made clear the terrible fragility and helplessness of flesh, its afterlife has demonstrated the remarkable power and durability of paper.

That is also the message of the commemorative exhibit, "Anne Frank in the World, 1929–1945," recently on view at the City Gallery. The show – some 600 photographic images and captions silk-screened onto 77 back-lit plastic panels – contextualizes the story of Anne Frank and her family within the larger tale of the Nazi occupation of Holland, and sets that within the frame of the "final solution" as the Third Reich rises and falls.

The exhibit tells the larger stories well, coherently and concisely. Yet its particular power comes from the inclusion of dozens of previously unexhibited photographs of Anne, her family and her friends. Until now, we have known Anne Frank's appearance by a mere photograph or two. However, it turns out that Otto Frank was not only a loving father but also a competent and persistent amateur photographer who photographed his family frequently. His images, captioned in a neat hand, were carefully pasted into an album. After the Franks' arrest, their looted household goods were transported to Germany. The album survived the move somehow, was preserved for reasons unknown, and, in 1980, was sent anonymously to the Anne Frank Center in Amsterdam from somewhere in Germany.

Its approximately 100 images allow us to put faces to the names in the Frank story – and, most poignantly, to put a progression of faces to Anne herself, hitherto known by only one or two images. Here she is shown from the day of her birth until roughly the time when she commenced writing her journal. This is a charming yet perfectly average family album, rendered extraordinary by external events. Now it is a haunted repository, not only charged with the auras of the individuals it depicts but also weighted with the absence of those millions whom Anne Frank has come to represent.

In Jerusalem, at Yad Va'shem, the Holocaust museum, there is a memorial to the 1,500,000 children who died as victims of Nazism. It is a darkened infinity of mirrors in which the reflections of burning candles stretch on

endlessly, as voices recite names, ages, and birthplaces. Visiting it, I thought of Anne Frank; looking at her in these images, so specific and alive, I thought of them all.

Aside from the direct memories of a diminishing few, paper is what we have left of them – paper coated with tarnished silver, paper inscribed with fading ink. What power there is in these flat scraps, dormant like seeds until they find fertile soil in the imaginations of strangers. Those who would own the world at any cost had best remember that even a 15-year-old girl who's almost half a century dead can reach a paper finger up from an unmarked mass grave to point them out.

This exhibit, and the new edition of the *Diary*, are among a number of commemorative events taking place around the world on this occasion. Another was the Leo Castelli Gallery's presentation of an "Anne Frank Series" by Doug and Mike Starn. This included a 3-dimensional floor piece, the "Anne Frank Grave Marker," which has been donated – along with all the Starns' profits from sales of the other works in the series – to the Anne Frank Center. To fulfill this commission, the Starns went to Amsterdam, visited the Secret Annex where the Franks and their friends hid for two years, and studied the material in the archives. The result is a set of 8 small pieces – positive transparencies derived from the family-album imagery and the manuscripts of the "Diary." Some of these were framed, some mounted under plexiglas, some merely pinned fluttering to the wall.

Aside from one grim piece which has the word "Jew" splashed across Anne's face in white paint, they are a melancholy, generally low-key set of meditations. The Starns' trademarks – patched and taped images, messily-glued assemblages, and jerry-built frames – are oddly appropriate here. Particularly touching is the "Grave Marker," a flat 20x24 inch piece in which diary extracts are overlaid on a set of head shots of Anne made between 1935 and 1942.

Still, they are somehow dissatisfying. I'm not one of those who believe that there should be no art about the Holocaust. Yet while the cause is certainly worthy, the Starns' work here is simply overwhelmed by the resonance of the original material. There are some things, no matter how mute they may seem, that speak best for and by themselves.

Letter from: New York, No. 5a

It's certainly easy enough for any dedicated follower of fashion to declare the late Minor White's work "outmoded." In a literal sense this is true – White's imagery, and his approach to photography, are no longer modish. Aesthetic hemlines have risen and fallen several times since White formulated and promulgated his ideas and produced his own major work.

But even those intent on consigning it to the dustbin of history should take a last, long, lingering look at it – if only because these pictures, unlike most of today's output, will sustain prolonged attention. That is no longer considered a virtue, but it once was, and it's important to understand a work in the context of its own time. "Minor White: The Eye That Shapes" provides us the first large-scale opportunity to do so since White's death in 1976. Organized by Princeton University's Peter Bunnell, this nationally-touring retrospective made its debut at the Museum of Modern Art in April.

White's generation of photographers, unlike ours, was not preoccupied with social theories of representation. Instead, they were concerned with vision – with learning to use their eyes in ways that would bypass mundane, habitual seeing. It was their belief that, if the impulses to literalize and to name could be suspended, then vision itself could function in a revelatory way. Washing the "windows of the soul" was the first step toward letting in the light.

Because many of these photographers were pioneering the formal teaching of their medium in the post-World War II academic environment, they also set out to produce the basic building blocks for a pedagogy, a history,

and a critical theory. Certainly they achieved at least the rudiments of all three, and White was seminal to all these efforts. Like most of his peers, White accepted Ansel Adams's dictum: "The negative is the score, the print is the performance." So he distilled the methodology of the West Coast's f.64 movement into the "zone system," codifying the craft in such a way that systematic control of the printing process became possible.

To emphasize the interpretive nature of the photographic process, he extended Alfred Stieglitz's concept of "equivalence," articulating a theory of the photograph as metaphor. To counteract the image glut that he (along with such others as Marshall McLuhan and Lewis Mumford) saw eroding people's ability to attend to any image at length, he constructed a remarkable set of meditational exercises drawn from such diverse disciplines as Zen Buddhism and Russian method acting. And to make all this as widely available as possible, he became the guiding light of *Aperture*, for almost two decades the only serious critical journal devoted to photography.

There were many, myself among them, who argued against some of White's ideas and activities, especially in his later years, when he began to believe his own press and don the mantle of the guru. But at least they were ideas worth arguing with, at a time when there were precious few of those being expressed.

Unfortunately, in the whirl of all his activity White's own work as a photographer tended to get lost in the shuffle, even while he was alive. Not that he himself neglected it, by any means. Quite the contrary: he left an extensive and carefully redacted body of work whose scope and scale is only hinted at by this ambitious, provocative and valuable reconsideration of White the photographer. The exhibit, with its accompanying major monograph, aspires to be nothing less than a critical biography of its subject. And, though I have some disagreements with it, I think it achieves that status.

Certainly no one is better qualified than Peter Bunnell to essay such an analysis. Bunnell, who began his work in the medium as a photographer and student of White's, now occupies the McAlpin Chair in the History of Photography at Princeton, which institution also houses the Minor White Archive. This project therefore resolves a lifetime of interaction between White and Bunnell.

White himself spent much of his time as a theorist establishing definitions, distinctions and categories. He also devoted much energy – as an editor and exhibition organizer/curator – to contextualizing the photographs of others, frequently taking extreme liberties with their work. Thus it's appropriate – perhaps even poetic justice – that Bunnell has structured the show so as to divide White's imagery into what he sees as its three essential attributes, and bollixed it chronologically so as to make certain recurrent issues evident by juxtaposing images from different periods of White's working life.

Most arguably, and most controversially, Bunnell has simply eliminated from the exhibit's concerns any trace of White's lifelong involvement with sequence form, one of the photographer's central concerns and major contributions. "Since I first used the term in 1948, 'Sequence' has grown in meaning," White wrote in his journal in 1961. "Sequence now means that the joy of photographing in the light of the sun is balanced by the joy of editing in the light of the mind." That quotation is taken from the monograph accompanying "Minor White: The Eye That Shapes" (Art Museum, Princeton University/Bulfinch Press/Little, Brown).

The quote indicates the centrality of sequencing to White's work; he saw it as a means for extending the medium's reach into poetry and metaphor. Indeed, the monograph includes more of White's own comments on sequencing, plus Bunnell's discussion of this issue, and also reproduces one example of what White called his "cinema of stills," the previously-unpublished "Totemic Sequence."

But none of the sequences are included in the show. The curatorial dilemma that led to this radical decision is this: Bunnell's thesis (and this is very much an exhibit with a thesis) depends on establishing the continuity of certain modes of vision – which partake, to varying degrees, of the psychological, the spiritual, and the erotic – and the recurrence of certain archetypal forms within the body of White's work. His points cannot be made without breaking the sequences down to their individual components. (He's also convinced that today's museum audience simply lacks the attention span necessary to give White's extended structures the contemplative space they require. Sadly, I fear he is right.)

Letter from

I consider White's sequences extraordinary. Yet, to my considerable surprise, I find myself not only in sympathy with Bunnell's dilemma but in agreement with his decision. The general audience's capacities notwithstanding, the sequences merit a full reconsideration in their own right. And Bunnell's strategy forces us to attend anew to White's individual images, which were rarely if ever made with a specific sequence in mind. The result provokes the viewer into re-evaluating White's imagery – and anything that achieves that end is, in my opinion, both laudable and valuable.

After all, curators are entitled to play a certain amount of hob with an artist's *œuvre*, so long as their deconstruction is intended to lead us to some new insight. In this case, Bunnell's risky gamble serves the work: it points us back to Minor White as a visionary picture-maker of remarkable power and authority who produced some of the most profoundly nourishing and pleasure-giving work in the medium's history.

What exactly is Bunnell's claim? To do it the injustice of synopsis, it's that White's relationship to the medium can be divided into three modes: "Possession," "Observation" and "Revelation." The first manifests itself as a passionate, even erotic identification with the subject; the second is a more distanced consideration of the visible world; and the third is a transcendence of the nominal subject, a passing through it. According to the curator, these correspond roughly to the stages of White's artistic life.

If this sounds mystical, that's because it is; White was a Christian mystic who brought elements of the thought of Gurdjieff, Ouspensky, and some of the eastern philosophers (primarily those of the Zen school) together to form a kind of jerry-built pantheism. Whatever its effect on others – and he became a proselytizer in his later years – it seems to have served him well as a picture-maker. One outcome of it was a meditative relationship to materials and process that partook of the sacral; the groundglass and, especially, the darkroom became confessionals wherein one bared one's soul.

The result of such introspective brooding was deeply-felt imagery whose every nuance was considered. White was a master printer – not an empty virtuoso like Ansel Adams, but a poet who understood how to carve emotions into silver. Some of the contact prints in this show are no more than 2x4 inches, which today sounds like some kind of absurd miniature. Yet

they are such tightly constructed tone poems that they have more resonance than just about any of the oversized wall accessories cluttering up SoHo galleries right now.

For that reason, White's work, though it reproduces well (and it's reproduced very finely indeed in the monograph) demands to be seen in the original. Part of the service this show provides is to present us with an extensive selection from his body of work: 185 prints, all of which (save for 10 color images) were printed by White himself. Many of them have never been shown before; others have not been exhibited for decades. Even for someone familiar with White's work, the exhibit is full of surprises. And the monograph contains not only several excellent essays by Bunnell, important extracts from White's writings, and valuable biographical data, but also an additional 100 images, arranged in strict chronology. A veritable silver mine, hinting at a mother lode that can only reward further digging.

I'm not sure I agree entirely with Bunnell's reconstruction of the *œuvre*. His pairings of related images, sometimes made decades apart, are astute, revealing the diverse ways in which certain iconographic ideas lurk persistently in an artist's thoughts and feeling. The larger categories are attractive conceptually, and do make another kind of order out of a large number of resolved images. But I kept encountering images in one section that seemed as if they could as easily have been placed in another – and kept recalling still other images, not in the show, that did not jibe with Bunnell's biographical reading of these modes.

Nonetheless, like the best of White's own theorizing, this is substantial food for thought. Certainly many aspects of White's work are manifest here. One of those is the unsuspected extent of his work with the male nude and the frankness of his unsensationalized homoeroticism. He was, in his imagery, out of the closet in the late 1940s – a good 3 decades before Robert Mapplethorpe. (In this regard it's worth noting that he generally titled his images, including his nudes, after their models, regardless of whether the faces were visible. Even a hand and a foot are given their owners' names – "William LaRue" and "Don Normark," respectively.)

The influence of abstract expressionism can also be seen here. An image like "University Avenue, Rochester, 1969" – which appears from a distance

to be a round black spot in the upper right section of a horizontal white rectangle – turns out to be a hole in a piece of cardboard in a window. The image is carefully printed so as to provide sufficient clues to permit this literal reading, but not enough to encourage it.

What does permeate the show is White's inclination to biomorphism, the reading of the physical world – including the natural world – for signs resembling human forms and human symbols. In rock formations he found phalluses and crucifixes, even the profile of a laughing skull ("Capitol Reef, Utah," 1962). Rust, frost and especially peeling became metaphors for ephemerality, the layeredness of the world. Like the good Christian mystic he was, White was drawn to that which suggested the insubstantiality of things, and that which held out the hope of transubstantiation. In his work the world we know is ultimately an illusion – to be contemplated, absorbed, penetrated, and finally transcended.

There's much more to be said, but for an audience most likely unfamiliar with White's work (especially in the original) a first-hand encounter is recommended, even urged. This exhibition and monograph make that possible; as a result, this project has my nomination as the most significant curatorial and scholarly achievement in photography of the 1988–89 season in New York.

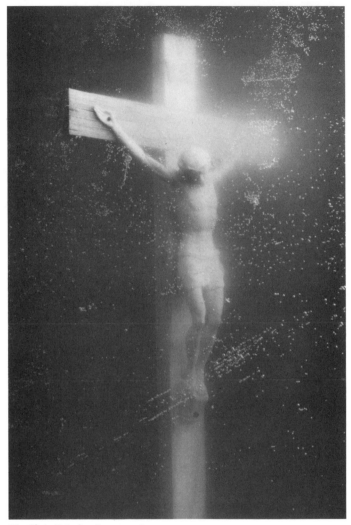

Piss Christ © Andres Serrano 1987
Courtesy Paula Cooper Gallery, New York

Letter from

Letter from: New York/Washington/ Rockport, No. 7

Back in the States after my sojourn in France, the first letters I pulled from the basket of accumulated mail turned out to be from thoughtful friends who'd clipped news stories and editorials about the current censorship flap – an imbroglio that the Europeans find incomprehensible, amusing, and somehow quaint. Hilton Kramer, Grace Glueck, John Russell and others have had their say on the matter, with countless more to come, no doubt.

Although the censorship of photography is a frequent occurrence, this has been a rare year to date insofar as it's already brought us three widely-publicized incidents of such suppression – the most recent being the Corcoran Gallery of Art's cancellation of the Robert Mapplethorpe retrospective that was scheduled to open there on July 1.

Having served as the founder and chair of the Committee on Censorship and Freedom of Vision of the Society for Photographic Education (the nation's only quasi-professional organization of post-secondary photography teachers), I'm in a position to testify to the regularity of such suppression around the country. I can also certify that the grounds are common and the issues recurrent. What is different – and, potentially, valuable – about these recent cases is the amount of public attention they've garnered and their consequent usefulness as springboards for a long-overdue debate on the subject of public subsidization of the arts.

First, a synopsis of the three cases. To begin with, the New Year in the Big Apple rang in with a brouhaha over an issue of *Nueva Luz*, a small-circulation publication which features imagery by minority photographers. This journal is issued by En Foco, Inc., a Bronx-based non-profit organiza-

tion. The offending issue contained some black & white nude studies of his family – including his children – by Brazilian-born Ricardo T. Barros. Brooklyn Assemblyman Dov Hivkind made political hay out of these, persuading the Bronx DA's office to investigate them as "kiddie porn." His claim to particular concern is that En Foco is publicly funded – to the tune of $20,000 this year – by the New York State Council on the Arts and the New York City Bureau of Cultural Affairs. So far, there's been no resolution to this "case."

Then there's the ongoing uproar over Andres Serrano's "Piss Christ," a color photograph of a crucifix submerged in a yellow liquid, purportedly the artist's own urine. Serrano was the recipient, in 1985, of an Artist's Fellowship from the National Endowment for the Arts. This particular image was chosen by the Southeastern Center for Contemporary Arts for a touring exhibition partly subsidized by further NEA funds; in that context it has been seen at such venues as the Los Angeles County Museum of Art and the Carnegie Mellon University Art Gallery in Pittsburgh. It's also been shown here in New York by the Stux Gallery, which represents the artist. No Rushdie-like death threats have been reported as punishment for his blasphemy, but thousands of fundamentalist Christian voters (not to mention 150 members of Congress) have written to the NEA on this subject, and such strange bedfellows as Jesse Helms and Al D'Amato are up in arms over the government's subsidizing of this artist and of his work's public presentation.

Then there's the Mapplethorpe show, containing a selection of sexually explicit, homoerotic images, as well as some problematic photographs of children, by the photographer who died of AIDS this past spring at the age of 42. Anticipating Congressional outrage over a presentation of this show (whose tour and catalogue have been supported in part by $30,000 in NEA funds) at the Corcoran (which last year received almost $300,000 in Federal funds), the Gallery's Director, Dr. Christina Orr-Cahall, in mid-June decided to cancel the exhibition's planned July 1 opening. Predictably, this did not prevent the House from passing a nonsensical and punitive bill that I can only hope will not survive its Senate gauntlet this fall.

Lamentably, Orr-Cahall's decision was supported by the Corcoran's board, whose chairman, David Lloyd Kreeger, said with equal courage, "It

Letter from

was a close call. If you went ahead, I suppose you could say you were up-holding freedom of artistic expression against possible political pressure. But you have to consider the larger picture . . . " As indeed you do. The de-cision to get involved in sponsoring this show would have been made in 1986. How could a museum director, deep in the heart of the Reagan Era, not foresee this problem?

Staying off the bandwagon in the first place would have done nowhere near the damage to the principle of freedom of expression that this craven leap from the moving vehicle has inflicted. For what it has provided is a clear demonstration of the Corcoran's willingness to sacrifice freedom of artistic expression in order to avoid possible political pressure. The Corcoran, as an institution, had a moral obligation to stick to its guns. Abnegating that responsibility was an act of self-censorship, plain and simple.

As it happens, I'm no great fan of Mapplethorpe's work. But that's not the question here. The issue in this case is the Corcoran's surrender before the battle was even joined. That capitulation is despicable.

It is also understandable, however, because we have as a nation failed to articulate any principles concerning government subsidy of the arts. We have instead adopted a bizarrely varied assortment of practices on the municipal, state, regional and federal levels, coupled with an even more demented and byzantine legal code in which the boundaries of the permissible are arbi-trarily and unclearly drawn. Consequently, arts bureaucrats like Dr. Orr-Cahall have no established precedents on which to rely. True to the survival instincts of their species, therefore, they tend to play things safe.

So, in light of these current cases, we might ask ourselves a few questions – in fact, we might urge not only such figures as Ted Koppel (who devoted one session of "Night Line" to the subject) but also Phil Donahue, Oprah Winfrey and even Mad Mort Downey, Jr. to ask them of us in public forums:

What are the differences between (a) commissioning the creation of specific works of art for public ownership and/or presentation in public places, (b) funding arts institutions involved in the publication and/or exhibi-tion of existing works of art, and (c) awarding grants of public monies to artists to support their pursuit of their own artistic ends?

What obligation, if any, does the public have to support the artistic avant-garde, however defined – or, for that matter, to support any work that any member of the public might find disturbing or offensive?
What obligations, if any, do artists and arts organizations have to the government institutions and/or the taxpayers from whom they solicit financial support?
What obligations do tax-subsidized arts-patronage institutions – like the various arts councils – have to defend vigorously the artists and artwork they subsidize, so that artists are not punished for sponsorial decisions that prove unpopular?
What public policies of government spending on the arts do we want, who shall administer them, and who shall we entrust with the assessment of the results?

The contextual uproar presently surrounding Robert Mapplethorpe's body of work makes it difficult to approach textually for the purpose of close reading and evaluation. Nor, for all its bravado, did the Mapplethorpe exhibit at the Washington Project for the Arts make it any easier to concentrate on what's on the walls. Quickly arranged after the Corcoran fled the field, clearly defiant of political pressure, and remarkably well-installed given the short notice, this show – with its attendant notoriety and crowds, a petition to Congress prominent at the front desk, and Nigel Finch's hour-long BBC documentary on the photographer playing continuously in the central gallery – could only be a media event.

Nonetheless, it was there to be seen – much of it familiar for anyone who'd followed Mapplethorpe's work over the years, with considerable overlap from the Whitney Museum show of several years ago. Most of it, as always, looked like interior decoration. This impression was reinforced by the various *objets d'art* the photographer manufactured: the mirrored "Star" and "Black X" of 1983, various images elaborately framed with pieces of mirror, others printed on linen and silk. All these designer gimcracks – "Heart and Dagger," 1982, is a prime example – would look great over the couch, but (like Busby Berkeley musicals) their elaborateness and extravagance of production is their only significant content.

Mapplethorpe's aesthetic was cobbled together from a hodgepodge of influences, primarily fashion and magazine-illustration imagery, with smatterings of theater/dance photography, celebrity portraiture and beefcake thrown in. Bits and pieces from Horst, Steichen, Barbara Morgan, George Platt Lynes, Imogen Cunningham, Anton Bruehl, Baron de Meyer, F. Holland Day, Kenn Duncan and sundry others are to be found therein.

Stylistically, Mapplethorpe was extraordinarily conservative. This is most obvious in the floral still-lifes such as "Urn with Fruit," 1987, which, however handsome, are little more than warmed-over pictorialism. But, throughout his

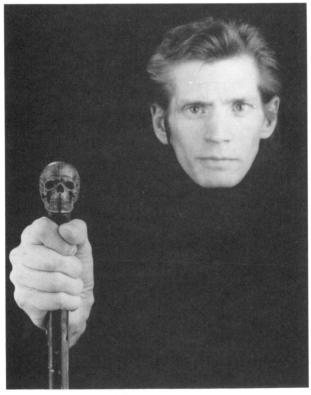

Self-Portrait, Robert Mapplethorpe
© 1988 Estate of Robert Mapplethorpe. Used by permission.

work, there's no exploration of the frame, nor of the pictorial space; whatever he wants the viewer to attend to is invariably front and center. This affirms his allegiance to the traditional notion that photography is subject-dominated: what matters is what he put before his lens, not how he saw it.

Mapplethorpe was not an innovator but an artist of sensibility, and a minor one at that. Though he has imitators, his work contains no germinal ideas; thus there's no basis for considering him influential. Portions of the "X" and "Z" portfolios – controversial due to their sexually explicit leatherboy content – will serve as documents of a curious sub-set of gay culture in our time. (Even here, though, the photographer's concern with the decorative keeps the imagery from getting too dangerous.) But such gay photographers as Minor White, Duane Michals, Arthur Tress – and, in their days, Holland Day and Platt Lynes – are the ones who really opened the closet doors.

If Mapplethorpe's remembered in the future, it will be as a portraitist. In that area, his stylistic conservatism and reliance on central placement serve the traditional goals of portraiture, while what seems to have been a genuine rapport with his subjects evoked their unfolding before his camera. With the unacknowledged collaboration of his anonymous but brilliant printer, Mapplethorpe made durable images of William Burroughs, Donald Sutherland, Louise Nevelson, Cindy Sherman, Doris Saatchi, Francesco Clemente, Alice Neel, Sam Wagstaff, Laurie Anderson and numerous others. He was at his best in the mode of transactional formal portraiture – and in his always-sad portrayals of himself, a moth who danced too close to the flame.

*

This octopoid crisis reached one of its long arms even into the bucolic backwater of Rockport, Maine, where the Fourth Annual International Photography Congress was held from August 13–19 under the auspices of the Maine Photographic Workshops. A Monday-evening audio-visual tribute to Mapplethorpe was followed by a Wednesday appearance by Andres Serrano himself, who presented an hour-long survey of his work in slide form during the afternoon and joined a panel that evening under the broad rubric "Artistic Expression and the Future," with Helen Marcus moderating.

Letter from

Along with Serrano on the panel were Roger Bruce, formerly with the NEA and the New York Foundation for the Arts; Robert Sobieszek of Eastman House; Brian Wallis, Senior Editor at *Art in America*; David Sidorsky of the Philosophy Department at Columbia University; and myself. Whether we generated any light I could not say, but most of us tried. Bruce outlined the policies and practices of the grants system at the NEA. Sobieszek showed and discussed some earlier controversy-provoking images. Sidorsky offered a closely-reasoned, subtle argument proposing that it was both inappropriate and hypocritical to seek public funding for certain kinds of art, for which he was unjustly (because inaccurately) cast as the villainous neo-con Helmssubstitute.

I was of three minds myself. While I think it's terrific that the entire country is acknowledging the potency and power of creative photography by furiously debating the cultural significance of some minor examples of that form, I also commiserated with Serrano. Back in my teens, I wrote a blasphemous play about the death of God (those were the days, my friend) that was published in the literary magazine of Hunter College. *The Brooklyn Tablet*, house organ of that borough's archdiocese, made it a *cause célèbre* and thereby nearly achieved the imposition of censorship on the entire City University system. So I've walked a mile in Serrano's shoes.

As a result, I'm a first-amendment absolutist. At the same time, I've come to the painful conclusion that I can't deny a vocal majority – or even a vocal minority – the right to exercise its ability to influence national policy. If I get to complain to my congressman about the insane decision to dock the USS Iowa, that floating nuclear Pinto, five blocks from my house, then others surely get to do the same when desecration of their icons is subsidized by the state.

I'd defend to the limit Serrano's right to make, exhibit, publish, sell, or transport his work across state lines, but no one is proposing that he be prohibited from doing so. They're suggesting that his activities not be supported with public monies. I don't believe that anyone has a right to no-strings-attached patronage; gifts of tax dollars are not owed to any artist. Consequently, I'm not convinced this is a free-speech issue. So I agreed with Sidorsky.

Needless to say, this assertion, coming on the heels of Sidorsky's carefully-argued position, upset many of those in attendance. Brian Wallis, who arrived late and used his turn to exhort the art troops into battle against the philistines, was aghast. So, from the audience, were Carol Squiers of *American Photographer* and Arthur Ollman of the Museum of Photographic Arts in San Diego. If there wasn't much light, there certainly was heat, and in its glow it was fascinating to watch where people chose to stand. Burt Glinn agreed with Sidorsky and myself; Arnold Newman didn't. As Freud would have asked, What do these photographers want?

And what of the eye of the hurricane, Serrano himself? The arch-fiend turns out to be a tall, squirrel-cheeked, taciturn 39-year-old guy who looks a decade younger. He played his cards close to the vest, contenting himself with reading a short handwritten statement and making three impromptu comments. He began by insisting that he had every right to apply for the grant he received and every right to spend the money as he saw fit (certainly true). Then he informed the group that none of this would deter him from making the work he wanted to make, which I was glad to hear. Unfortunately, he also said, repeatedly, that he has no interest in how other people respond to his work, because he makes it only for himself. I thought this statement was ill-advised, because in my opinion it enunciates succinctly the posture of the perpetual amateur – and professional "peer panels" have no business awarding public monies for the arts to amateurs. But that's another discussion.

In any case, though the debate raged well into the night after the panel disbanded, it all ended more or less amicably. (To my surprise, Serrano even asked me afterwards if I was of Hispanic descent.) Indeed, the closest anyone came to fisticuffs all week was the next morning, when Wallis's adulatory presentation on the subject of Richard Prince's "Marlboro Man" appropriations came up against cowboy photographer William Albert Allard in the flesh. It was one of the stranger squarings-off I've ever seen in the wonderful world of photography. Surreal and revelatory moments like that – along with the Maine air and the siren song of the lobster – are what make the Maine Congress memorable.

Letter from

Letter from: Amsterdam/New York, No. 8

Though I'd begun to suspect it awhile back, my travels this year have con-
vinced me that the field of photography is undergoing a sociopolitical
transformation: it is turning multinational. That development, while it will
surely prove problematic, now seems inevitable.

It is clear – from the thousands of special events taking place this anniver-
sary year; from the longevity of such ongoing events as the Arles Festival,
Houston FotoFest, and the International Photography Congress in Maine;
and from the proliferation of organizations, institutions, biennial events and
publications we're now witnessing – that an international image community,
an "IIC," is emerging to match the EEC (European Economic Community)
scheduled to debut in 1992.

This may well be to the benefit of our field. After all, our assumptions
about photography, on every level from history and theory to practice, have
been based on western European and North American models and attitudes.
There was good reason for this: photography was the outcome of a specific
phase in 15th- and 16th-century European thought. Yet, immediately upon
the announcement of its invention, mercantilism and imperialism dissemi-
nated it rapidly to all points of the compass.

As a result, photography became a global phenomenon. This recognition,
though slow in coming, is now upon us. The old hegemony is crumbling;
emergent in its place is an insistence on exploring what Naomi Rosenblum
properly calls "a world history of photography."

Evidence of this tendency was everywhere this year, evoked particularly
by the countless sesquicentennial celebrations. Nineteen-eighty-nine has

been the occasion for every nation, state, city and town to investigate and establish its role in the medium's evolution. It's also been an unprecedented opportunity for cultural exchange. I'd guess that far more photographic images, texts, photographers, scholars and functionaries have crossed borders this year than ever before, with the consequence that any lingering naive parochialism in regard to the medium is gasping its last.

This is not to say that the transition to this new condition is easy. In late August I found myself at a symposium in Amsterdam, "The Other Side of Photography: Profiles of Education." Sponsored by a consortium of Dutch organizations, the gathering was held at the Gerrit Rietveld Academy between August 28–31. Some 300 students and teachers from two dozen photography programs across Europe came together to discuss the state of photo education, to look at a cross-section of the work currently being produced in their schools, and to listen to such speakers as Bill Jay (US), Jean Arrouye (France), Günter Rambow (Federal Republic of Germany), Robert Pledge (US), Vladimir Birgus (Czechoslovakia) and myself. . . .

What will come of this meeting I cannot even predict; it's too soon to tell. But everyone seemed energized by the event. Various exchange activities, both formal and informal, were initiated. There was even talk of founding a European organization for photography teachers, as a means of carrying forward what this assembly had begun.

On the day that the education conference closed, Holland FOTO-89 opened. FOTO-89 was yet another 150th-anniversary mega-event: 60 shows, plus dozens of lectures, panels, film showings and related activities spread out all over Amsterdam for the month of September. Organized by writer Herman Hoeneveld and Jacques van de Vall, this was the third international photo festival in the city (its predecessors took place in 1984 and 1986.)

What function is served by such extravaganzas? Surely not the process of coming to terms with the pictures themselves. These three-ring circuses tend toward a pictures-by-the-pound attitude, jamming as much diverse work as possible into spaces not always suited for any of it. The core of FOTO-89, for example, was a grab-bag of 20 exhibitions – everything from solo shows of work by P. H. Emerson, Arnold Newman, Elliott Erwitt and Dennis Hopper to surveys of contemporary pinhole photographs and Czech

imagery – all packed into the Nieuwe Kerk, a beautiful historic landmark that was never intended to house such imagery in such volume. So, in Procrustean fashion, an elaborate modular panel system was devised to hang the work and make the lighting of it possible – with the result that any sense of the scale and space of the Gothic church itself was lost.

If they are not ideal display venues for attending seriously to images, these galas do work as bazaars, marketplaces for imagery and exhibits thereof. Like boat shows, auto shows, and assorted other expositions, they give the international photo community a chance to sample a variety of different projects, many of which are available to travel to institutions around the world, where they may be presented (and attended to) in calmer fashion.

Also, by generating more publicity than any one of the shows might garner on its own, these collections draw public attention to the medium itself. Extensive TV, radio and print press coverage invariably results, whereas the media still pay little attention, either journalistic or critical, to individual photography books and shows. So a certain amount of public education takes place, especially when amplified by the coordinated cooperation of local schools and civic groups.

Too, there's a consciousness-raising effect to all the hoopla. Even if superficial, that heightened popular awareness of activity and energy in photography helps to create an atmosphere in which photography is taken a bit more seriously – so that requests for support of photographers, photographic projects and photography institutions are therefore given more consideration. (If that smacks of what's now called "perception management," photographers – being in the perception management business themselves – can hardly object.)

Finally, by their very nature as international spectacles, these expos encourage the exposure of assorted rarities and lesser-known works. For instance, such events have been instrumental in bringing to light an enormous amount of imagery from eastern Europe, both historical material and current work; the Czech survey that was included in FOTO-89 is only one example of this not insignificant contribution to *glasnost*. Work from third-world countries is also received more hospitably by these venues than by most museums. So, for those willing to wade through crowds and sift through

mounds of imagery, there are opportunities to see important material one will not encounter elsewhere, or to run across a resonant manifestation of culture like the "Kaiserpanorama," a late 19th-century room-sized console of stereo viewers which could handle two dozen people simultaneously looking at different images.

Do the benefits of these biennales outweigh their drawbacks? Regardless of the answer, we're headed in the direction of the more the merrier. At the opening ceremony for FOTO-89 on August 31, Jean-Luc Monterosso of Paris Audio-Visuel, the organization that sponsors the biennial "Mois de la Photo" in Paris, announced the founding of a European Association of Photo Biennales (APB). This association is already committed to involvement in upcoming festivals in Barcelona, Paris, Athens, Turin – and Amsterdam, for FOTO-91. The notion of franchising photo festivals makes me wary, even nervous. But trade tends to bring with it the expansion of knowledge, free-thinking, and peace. We'll see.

Letter from: Goteborg/New York, No. 9

Krzysztof Wodiczko's installation on the subject of the homeless at Exit Art was part photography, part video, part sculpture, utterly lunatic, probably prophetic, and right on the money.

The work consisted of two parts. One was a large, darkened area on whose walls were projected "panels" of images. The projected image, a dematerialized form of art, is one of Wodiczko's specialties. Often he employs this medium outdoors, and at night; he's beamed photos of missiles onto the Grand Army Plaza Arch and a swastika onto London's South Africa House. Here the images were staged scenarios involving apparently homeless people – "evicts," the artist terms them – armed and barricaded, preparing for pitched battle against unidentified forces.

The six largest "panels" filled the wall from floor to ceiling. The central one bore the exhortation, "Evicts of all cities, unite!" The others were tersely titled "The Exercise," "The Barricade," "The Briefing," "The Transmitter," and "The Guard." Though they were only simple snapshots, virtually styleless, they managed to evoke both the historical reality of *Les Miserables* and the apocalyptic fantasies of *Road Warrior* and *Escape from New York*.

In the adjacent room there was an abundance of material concerning "The Homeless Vehicle Project," Wodiczko's collaboration with David Lurie. The vehicle itself – a prototype of which sat in the center of this space – is a form of porta-home. Constructed of aluminum, plywood, orange plastic and rubber, it is a combination shelter and bottle-collection device on wheels. Collapsed, the vehicle is slightly larger than a supermarket cart; it provides storage space for personal effects and a large basket for recyclable containers.

Fully expanded, it is about nine feet long, offering a plywood platform for sleeping, a storage shelf, waterproof covering and ventilation. In both conditions it looks ominously like a missile, due partly to its rounded contours and partly to its pointed metal tip (a built-in begging bowl).

This is a genuinely demented artifact, the kind of solution you'd expect one of Reagan's or Bush's minions to propose in all seriousness as a sufficient response to "the homeless thing." Wodiczko and Lurie surely understand its satiric function, but their satire is savagely effective only because they've spent their energies in refining the vehicle so as to make it truly functional. As a result, while one side of the brain recoils at the monstrous social conditions that would spur the invention of such a device, the other side wonders why the government isn't mass-producing them. (I mean, hey, this thing could work!)

In a thoughtful, closely-reasoned statement of purpose that served as the exhibit's wall label, the collaborators described the vehicle as part of "a strategy for survival for urban nomads – evicts – in the existing economy," for whom it can serve as "both emergency equipment and an emergency form of address." They went on to say, "It recognizes and addresses the claim of the homeless to citizenship in the urban community, both as refugees from the physical transformation of the city and as working people."

Indeed, the vehicle has been tested in New York (where Wodiczko has been working with homeless people living in Tompkins Square Park) and Philadelphia; prototypes were on the streets of both cities during the course of this show. Part of this installation included a wall of photos showing the vehicle in use in the city, and a parallel videotape.

The latter was evidence of a culture gone truly insane; in it, as a fellow named John, himself a can and bottle collector and evict, wheeled this bizarre object along the streets and avenues of Manhattan, people gathered around and clamored for demonstrations – and then (though the soundtrack was unfortunately murky) commented to John and each other about the ingenious design, for all the world like browsers at an auto show discussing the options on the new Mazda hatchback. (I mean, hey, this thing could work! Survival equipment for the homeless is a growth industry!)

Letter from: New York, No. 10

The International Center of Photography exploited the capacities of its newly-enlarged exhibition facilities by presenting two intertwined shows, devoted to the first forty years of the cooperative picture agency Magnum, at both its locations. The midtown space contained "In Our Time: The World As Seen By Magnum Photographers," a 300-print traveling retrospective accompanied by an equally elaborate book; this was complemented by "Magnum Founders: Robert Capa, Henri Cartier-Bresson, David Seymour 'Chim' and George Rodger," a set of four fifty-print shows at the uptown site.

Let me begin by saying that all these shows, and the book, are full of powerful, affecting images. Many will be unfamiliar even to followers of photojournalism; many more are not only memorable but remembered, images that have become iconic in our culture. There are therefore two reasons to recommend this two-pronged survey to your attention. One is for the pleasure of seeing a great many fine photographs. The other is for the opportunity it offers to learn from the enormity of this project's failures.

There's nothing wrong with the project's conception. As a pioneering cooperative, founded in 1947 by photographers intent on retaining control over not only their negatives, prints and copyrights but over the usage of their imagery, the agency – which was Robert Capa's brainchild – anticipated by a decade and half Roland Barthes's realization that the meaning of photographs was constructed contextually, by the juxtaposition of image against image and/or image against text.

Magnum's efforts on behalf of the creative and political autonomy of its members have influenced the entire field; the work that resulted from this

ongoing battle – the individual images and photo essays – have had a definite effect on all cultures where photographs circulate freely. While the agency, now well-established and no longer an upstart, has imitators and even challengers, it remains a major force to be reckoned with. So an analysis in depth of the first four decades of its activities promises to be rewarding.

But what we have here is no such analysis. Neither show does justice to what the agency has achieved. The uptown show establishes useful reference points by providing a survey of the four founders' work, mixing well-known and less-familiar imagery. But the prints are generally mediocre, much less interesting to look at than the magazine and book layouts and tearsheets that reveal how the images were used – for most of these pictures were, after all, made not for the wall but for the printed page. Regrettably, there are only half a dozen such samples in the entire show, and a minimum of other contextualizing data (the biographies are sketchy at best).

If this show is disappointing, its midtown companion is a grotesque travesty – exactly the kind of decontextualized mish-mash of imagery the organization's founders banded together to defend themselves against. Photographs in wildly divergent moods about vastly different subjects, made by different photographers in different countries and different decades, minimally captioned (often by no more than the date and place of their making), were butted up against each other in no order that I could determine even after two visits.

Yes, there was a "New York" wall, with everything from one of Bruce Davidson's lyric paeans to adolescence (from his 1959 "Teenage Gang" suite) to a pair of brutal, Weegee-esque murder scenes from Leonard Freed's 1972 report on city cops. Yes, there were "Latin America walls" in both color and black & white – not to mention three Middle East walls, a small room divided between India and the Orient, and a gimmicky "back of their heads" triptych. But that's the closest thing to a rationale for selection and sequencing that the show had to offer.

Given that the agency prides itself on providing its members the support necessary for pursuing their projects at length, it's incomprehensible that rarely were two images by any photographer shown side by side in the midtown survey – and that not one single essay by any of the dozens of

photographers who've been part of the agency's roster was presented in toto. There were a few panels which reproduce the finished, published layouts of selected stories; but these were clearly intended primarily as design elements in the exhibition's layout, placed and scaled in such a way that the pictures and texts were hard to read.

Rather than explore the meditative, analytic, interpretive capacity of the photojournalistic essay at its best, this hodge-podge imitates television newscasts at their worst, serving up a mad jumble of glimpses of an incoherent, senseless world – here a landscape, there a revolution, next a sight gag and then a portrait. This is a three-ring circus, a spectacle with something for everybody, which – like a Barnum elephant in a tutu – is at once ponderous and trivial. That it is not meant to be taken seriously is clear from the accompanying videotape (funded by Eastman Kodak), in which a relentless barrage of clichés is relieved only by the bizarre sight of Elliott Erwitt and Burt Glinn wandering around aimlessly, making small talk and dumb jokes, all tarted up in hooker wigs.

If only because it is no different yet more permanent, the book version – weighing in at a hefty six pounds (W.W. Norton) – is even worse. It opens with an essay by William Manchester, who, obviously having nothing particular to say about photojournalism or any of these pictures and unable even to spell Napoleon's name correctly, instead offers a scrambled synopsis of the last 40 years of world history and a bollixed rehash of Beaumont Newhall's version of the entire history of photography. For example, his explanation of the halftone printing process is simply incomprehensible; and when he mentions the stereograph as a form of imagery, he's clearly unaware that the stereo card was perhaps the earliest form of mass-audience photojournalism, with an international audience of millions.

Jean Lacouture follows with a hagiographic paean to the founders that probably reads better in French. Then there are the images, beautifully reproduced, in a different but no less eccentric sequence than that of the exhibit. Finally, there is the only discernible attempt to make order out of chaos: Fred Ritchin's dependably thoughtful, solid consideration of the agency's work and its impact on the medium. Valiantly though this tries to pull it all together, his effort is doomed; by then it is too late, and the scat-

tering of yet more randomly-selected images through his text nails the coffin shut.

The structure forbids any tracing of the development of any individual photographer's work, any chronological shifts in the agency's coverage, any constructive comparison between photographers, or any scrutiny of the evolution of the published photo-essay as a form of communication. So there are any number of important questions that go unasked here. For example, to what extent has the increasing tendency toward a personal, lyrical poetry on the part of the members undermined individual and collective engagement with the demands of epic storytelling? And how has the solicitation of highly-paid annual-report hackwork for leading corporations affected what was initially an anarcho-syndicalist collective? These queries are nowhere voiced, though the show itself could be seen as a pathetic, tacit answer to them.

Who is to be held responsible for this lunacy? One can point to Ritchin and Robert Delpire, who are co-credited with selecting the work (Delpire sponsored the show's debut at the Centre Nationale de la Photographie in Paris), or to the ICP's exhibitions curators and publications team, or to ICP head Cornell Capa. But I think that the only response that would be true to the spirit of Magnum – a spirit that I fervently hope will survive the disaster of this show (especially if it proves to be, as it very well might, a popular success) – is that Magnum itself is responsible: the agency has had input into and control over this show and book all along. And the agency, as they keep insisting, is no one but its members. The accountability, then, is theirs. It will be instructive to see – once the dust settles – where they allow the blame to fall for this fiasco and what (if anything) they learn from it.

*

The Whitney Museum of American Art, meanwhile, was offering up an extravaganza of its own. "Image World: Art and Media Culture" sought to provide an overview of the ways in which North American artists have responded to an increasingly media-dominated environment over the past three decades. Organized by Whitney staffer Lisa Phillips and guest curator

Marvin Heiferman, with the assistance of Whitney film and video curator John G. Hanhardt, the show contained over 100 works by more than 60 artists and "artists' collectives," plus an elaborate accompanying program of film and video screenings at the museum, a Krzysztof Wodiczko projection on the museum's facade, and off-the-premises billboards and installations by Barbara Kruger, Lorna Simpson, Gran Fury and others. An elaborate catalogue is an integral part of this enterprise, which was sponsored by the Polaroid Corporation.

Even after two visits and prolonged reflection, I am at a loss to explain how this exhibit managed to be both overstuffed and barren, clangorous and mute, affectless and pathetic. Heiferman, in a bit of fancy footwork doubtless intended to let himself off the hook, claimed in a National Public Radio interview that the show described "an historical moment that has already passed." Surely it's odd to hear a curator admit that his exhibit of purportedly avant-garde work is an instant period piece. Still, if so, one can only be grateful for small favors.

The anomie, alienation, and cynicism with which "Image World" was permeated left me grieving for the generation that have grown up with this calculatedly repellent trivia touted as the cutting edge in art. How anyone young could make art in such a context – indeed, why anyone young would want to – are questions I could not possibly answer. The show's reply, by contrast, is short and sweet: you make art nowadays so as to get rich and famous.

Ours is not the first culture to find itself in decline, but I know of no other that has enticed so many artists to wallow in its decay. Abandoning the crude, inchoate, but energetic critique of mass media that began to emerge in the art of the 1960s, we have (if this show is any indication) somehow surrendered to a high-tech, open-armed embrace of those same media – including a loveless but frantic coupling with advertising, that force which now drives not only the art-marketing system but the lives and even the work of many artists.

Entranced more with the notoriety of its exhibitors than with their work – except when, as is often the case, the two are identical – the show pays its closest attention to their panting liaison with hype. These artists,

quite a few of whom are connected with the Disney-funded California Institute of the Arts, seem motivated mainly by the ardent yearning to be known throughout the length and breadth of greater SoHo – which, if this exhibit's diagnosis is accurate, is turning into an east-coast division of CalArts that, in conjunction with its west-coast counterpart, will form a new bicoastal theme park: Walt Disney's Art World.

The lens image in its various forms – still photography, film, and video – naturally dominates the show, as it's the principal communication device for the creation of a media culture. Even works in other media – the drawings of Robert Longo (actually commissioned by him from a commercial illustrator), the paintings of Chuck Close and John Clem Clarke – are derived from lens-formed images, or made to resemble them. Represented, too, are such photographers as Cindy Sherman, William Wegman, Robert Cumming, Clegg and Gutmann, Frank Majore, and Laurie Simmons; appropriators like Andy Warhol, Sarah Charlesworth, Richard Prince, and Allan McCollum; assorted photocollagists, including Robert Rauschenberg, Barbara Kruger, and the severely underrecognized pioneer Wallace Berman; and an assortment of other, even less categorizable folk who work with the photographic image and/or photographic materials: Annette Lemieux, Nancy Burson, Hans Haacke and more.

Oppositional works like Robert Heinecken's altered magazines from the early '70s – wherein appropriated Vietnam-war images were anonymously silk-screened into copies of mass-circulation magazines which were then reintroduced into circulation – get comparatively short shrift. Today they seem small, quaint and primitive in comparison to some of the glitzier recent works on display. Yet Heinecken's more recent forays into media criticism – including such acidulous works as the "Inaugural Videogram" series and the ideal-TV-anchorperson fiction – are not represented, though they not only could hold their own with, say, Sherrie Levine's "President" series but would also indicate Heinecken's long-term commitment to deconstructing the media.

Notable by their absence, too, are representative works by photographers who consistently addressed the media's invasion of quotidian life. I think here of Robert Frank, Lee Friedlander and Garry Winogrand, to name only

Horned Cheer © William Wegman 1978
Courtesy Holly Solomon Gallery, New York

three now-senior figures whose analytical images of mass-media's intrusions into the everyday were seminal. Such deliberate omissions serve the curators' thesis, which is that a critique of mass media's impact on culture has emerged, evolved and become more sophisticated since the late 1960s.

In fact, however, the evidence on exhibit contradicts this, suggesting instead that the critique has devolved, deteriorated and become hopelessly, willingly co-opted. Most of the work on view has succumbed, in the most

round-heeled fashion, to the fallacy of imitative form. How else are we to read the following progression? First we are given a room whose perimeter is lined with dozens of ads in which noted artists either apply their talents to the production of advertising imagery (David Levinthal's 20 X 24 Polaroid "Absolut Vodka" ad) or else promote the products – liquor, jeans, whatever – with their faces and the cachet of their celebrityhood. Thence one can go to the wall that contains advertisements for themselves by Ingrid Bengis, Ed Ruscha, Jeff Koons and others. And from there it's but a short step, literally and figuratively, to Ashley Bickerton's "Commercial Piece No. 2," a willfully ugly construction on which the artist sold advertising space to various manufacturers for the display of their logos.

The curators' assertion that these artists have familiarized themselves with snippets from the currently fashionable footnotes – Lacan, Baudrillard, Foucault, Barthes, Kristeva *et al* – hardly guarantees the political or aesthetic integrity of their works and deeds; at best, it only verifies that disaster predictably results when theory is taken as prescription rather than as provocation and speculation. As Marcel Proust once said, "A work of art that parades its connection to some theory is like a garment whose price tag is still attached."

However, these presumed sources are dutifully trotted out by the curators in their catalog essays, which are nonetheless readable – and surprisingly noncommittal in relation to the work they're sponsoring. One can understand the curators' impulse to distance themselves from this stuff, most of which has actively divested itself of anything Walter Benjamin would recognize as aura (the bulk of it, significantly, looks as good or better in reproduction than it does on the wall). Its dominant attitude – ah, that keynote of the '80s – is disdain. That's a peculiar tone for work that, virtually by definition, is meant to be understood as social art – that is, as work concerned with social issues. How sad and symptomatic that so many of the best-known artists of the current generation have been reduced to such posturing. Perhaps the erroneous equation between best-known and best, initiated by St. Andy, is at the root of this ailment. For, in the truest, deepest sense of the word, much of the work in this show is not healing but diseased.

Letter from

Coming to Rest © Vito Acconci 1969
Courtesy Barbara Gladstone Gallery

Even an older figure like Nam June Paik has become infected with this virus, as proven by the two pieces with which he's represented in the show. The first, "Fin de Siecle II," an installation created for this show, greets you at the exhibit's entrance. An ear- and eye-splitting assemblage of 300 TV sets controlled by analog computer, it's a disco from your worst nightmare, a music video from hell in which Joseph Beuys and David Bowie conflate endlessly. But turn the first few corners into the 1960s room and you'll find

Paik's "Magnet TV" from 1965, a small black & white set with a heavy magnet atop it, distorting the commercial-network projection into an abstract kinetic pattern. Elegant in its simplicity, it is the purest guerilla action, a clean gesture that seizes control of the tube with a true economy of means. It's a far, far cry from the model for a fascist paradise that he's concocted as the show's pre-emptive first strike.

There is some substantial work here, to be sure, as well as a scattering of less-than-first-rate work by artists who have elsewhere proven themselves to be substantial or at least shown promise of becoming so. But a decade from now I doubt that anyone will be looking closely at most of this stuff, especially that which dates from the '80s. I'd venture to predict that affect, aura, and mutual respect between artists and their audience will be resurgent between now and the year 2000 – and that the artists from the '80s whose achievements we'll be celebrating ten years hence are those who've been working away patiently, in silence, rather than the ones who've spent their quality time busily making their names into household words.

Letter from: New York, No. 11

Roughly a year ago in this space, I discussed at some length a single Cindy Sherman image. In many ways a departure from her earlier work, yet very much related to it, the image was a sumptuous, elaborate parody of Renaissance portraiture, with Sherman presenting herself as Madame de Pompadour, mistress to Louis XV.

At that point, the work was anomalous in Sherman's *œuvre*. Evidently, however, it was part of a larger project, the mere tip of an iceberg. Several more selections from this series recently made their debut in the Whitney's controversial "Image World" survey, and a full look at it – 22 pieces in all – was recently made possible by Metro Pictures. Taken as a whole, this suite makes the body of her work to date seem like a set of student exercises leading up to this first mature performance.

The new series is both willfully outrageous and deeply comic. Sherman has been in Italy recently, obviously spending some of her time soaking up the art-historical riches of the continent. Now she has reinterpreted them, complete with all the conventions, mannerisms, and trappings – the gilt, lace and brocade, the caps and fans and fruit, the poses and gazes, even pared-down versions of the fancy frames.

I've rarely found her impersonations convincing in the past, but this is a veritable *tour de force*: she enacts all the roles – people of all ages and physical types, male as well as female – marvelously well. By turns she is courtesan, madonna and scholar, lord and lady, doe-eyed pregnant nude and simpering cleric, tubby bald-pated monk and hairy-chested cavalier. And she is credible as each, despite the fact that something in almost every

image deliberately gives the game away. These transformations are accomplished with costumes, wigs, mustaches, make-up, assorted fake body parts (bosoms, noses, warts), adroit lighting and a keen awareness of gesture and body language. There is no attempt to disguise the theatrical illusion; the seams are allowed to show, as in an Arcimboldo seen up close. For example, the same false schnozzes reappear in images of her playing half a dozen roles of both genders; elsewhere, a string of pearls partly disappears behind the visible top edge of a plastic bosom.

These pieces vary considerably in size, from 25 x 18 inches to 88 x 57; one is oval, some are close to square in format. In short, each one appears to have been individually conceived. I suspect that every one is derived from one or another particular work; no doubt some eager art-history grad student is already tracking them down for us. In any case, taken as a group they offer a short course in painterly strategies for celebrity portraiture between 1600 and 1800. All the pictorial devices used by artists of that period (and even since) to construct mood, character, class status, occupation, gender, even gender preference are deployed forthrightly and cheerfully, in the manner of a vacuum-cleaner salesman giving a living-room demonstration.

And, as happens with any good sales pitch, one finds oneself wanting to buy. These are astute, clear-eyed deconstructions of a system of representation designed to glorify the moneyed and privileged – in that sense, a style of imagistic hype. Yet they are so well-crafted, so engrossing in their sensuosity and tactility, that the viewer wants to suspend disbelief and engage with the transparently fictional persona being presented in each of them, even while some radically opposite, contradictory one hangs right beside it.

That seductiveness makes the unavoidable awareness of their illusory nature, which although right on the surface still comes as an after-effect, all the more powerful. There is a curious, genuine affection in the thoroughness with which they mercilessly roast their models, something akin to the candor that emerges when all members of a nuclear family finally learn how to accept and talk to each other, warts and all.

The laying bare of those visual codes by which we construct identity in images has long been Sherman's concern. But the tone of her inquiry has usually struck me as defensive, snide, and distanced. By contrast, the confi-

Letter from

dence and comic exuberance of these works is palpable, and their effect on the viewer is immediate. I found myself looking excitedly, walking around and laughing out loud – in a room full of other people doing the same. That's a rare enough experience in the New York art scene that I'm planning to return in the company of friends. This may well prove to be postmodernism's first long-running comedy smash.

Untitled © Cindy Sherman 1989
Courtesy of the Artist

With the broadcast premiere of Kirk Morris's biographical docudrama, "W. Eugene Smith: Photography Made Difficult," over PBS nationwide late last fall and the virtually simultaneous publication of *W. Eugene Smith: Shadow and Substance* (McGraw-Hill), Jim Hughes's long-awaited biography, some might think that 1989 was the year Gene Smith came back to haunt us. For Smith embodied the uneasy conscience of photojournalism and of photography itself, which neither can nor should ever be laid to rest; and these two independent, unrelated projects make clear the continuing urgency of the questions raised by Smith's ideas and work.

Both these ambitious enterprises are, inevitably, flawed; Smith was a larger-than-life entity who ultimately evades capture in prose or re-enactment. It's noteworthy that both projects are driven to epic scale in their attempts to encompass him (the Morris film is 90 minutes long rather than the usual hour allotted to such profiles, and the published version of Hughes's book, a dense 550 pages, was carved from a manuscript at least twice that size). This is appropriate not only because Smith's life was exceedingly complex and tormented, but because he remains one of the medium's few epic poets – and, arguably, its greatest.

Smith was among that handful of individuals capable of conceptualizing photographic works with the emotional resonance, dramatic richness and narrative sweep required by the form to which he was drawn. The themes and issues one grapples with in epic form are the big ones – life, death, madness, war, loss, the struggles between love and hate, good and evil. These obsessed Smith from his adolescence on; reconciling that with the exigencies of the photojournalist's working situation was the dilemma that preoccupied him once he decided, while still in his teens, to make photojournalism his profession.

As Hughes makes agonizingly clear, Smith took the resulting frustrations out on himself – through overwork, an inability to effect closure in almost every area, general recklessness and habitual substance abuse. He became a classic manic-depressive alcoholic with a positive genius for identifying and exploiting co-dependent tendencies in those he encountered, especially young women. Hughes is at his best in unraveling the knots and snarls of Smith's personal and professional history. Piecing this patchwork quilt together

Letter from

from assorted public and published sources, countless interviews, and the massive archive Smith accumulated around himself (he shipped 44,000 pounds of stuff to the Center for Creative Photography in Tucson a few years before his death), Hughes produces an engrossing account of the texture and quality of Smith's workaday life and personal environments.

The book is heavy going – because Smith himself was. By halfway through, one feels oneself sinking into the miasma that was Smith's psyche and, by extension, his life. Even as a reader, there is only so much of this one can take. And yet . . . and yet, there is the work. For out of the disaster and the shambles of this life there emerged some of the most important imagery – and some of the most brilliantly redacted work in extended form – of photography to date. Imagery that resonated around the world; imagery that (perhaps due to Smith's perpetual entrapment in failure, defeat, isolation and pain) renders and evokes the psychoids of oppression more articulately than any that preceded his.

"Where the accepted approach in photojournalism . . . had been for the photographer to put himself in the reader's place, Gene had found a way to put himself in his subjects' place," as Hughes points out. In that empathy with the trapped and damaged – in whom, doubtless, he saw himself – lies the source of his faith in the possibility of healing, so central to so much of his finest work: "Country Doctor," "Nurse Midwife," the Albert Schweitzer essay and, of course, the Minamata story, one of the unquestioned masterpieces of photojournalism.

It is to the credit of this biographer that the work does not play second fiddle to the barely controlled dementia of Smith's personal and professional circumstances. His life was full of the stuff that stokes the gossip mills. Hughes tackles all of this head-on. Yet the urge the book generates, at its conclusion, is not the pursuit of more juicy tidbits, but the replenishing encounter with the work itself, which is where Gene Smith put the best of himself.

"Writing a biography," the film critic P. Adams Sitney has said, "is a process of falling out of love with your subject." Certainly, by the end of this one, the reader has fallen out of love with Smith. His death in Tucson, Arizona, in 1978, at the age of 59 – nominally from a cerebral hemorrhage,

though in truth he died, as someone once said of Charlie Parker, "from everything" – comes as a relief. It must have been such for all those who cared for and were involved with him – even, perhaps especially, for the man himself, an "authentic genius" (according to psychiatrist Nathan Kline) who, not by choice but chased by his own Furies, spent an eternity in hell during his time here on earth and devoted himself to speaking to and for the mute among the damned.

*

It's always been curious to me that so many people consider photographs to be silent, because I not only see them but hear them as well. Photography is, after all, a tonal art form; it's no coincidence that so many photographers have been either musicians (Lisette Model, Wynn Bullock and Ralph Gibson are only three) or else listeners avidly drawn to music, nor that practitioners as diverse as Alfred Stieglitz, Ansel Adams, W. Eugene Smith, and Roy DeCarava have likened photography to music and based their thinking about the medium on that analogy.

In "The Appearance of Sound," her installation at the New Museum of Contemporary Art, Annette Lemieux treats photographs as auditory phenomena on a different and more literal level. Through a kind of synaesthesia, the work is intended to evoke in the mind's ear the sounds of what the imagery depicts or implies, via visual (and, sometimes, textual) cues.

Though referred to by New Museum curator Susan Cahan as "paintings," the six pieces that comprise the installation all have as their central components vastly enlarged "found" photographs transferred to canvas. To these the artist has manually added graphic elements; she has also affixed objects to some of them, turning them into photocollages, assemblages and sculptures.

For example, in one of the most successful, "Stampede," the horizontal image – roughly 7 x 14 feet – depicts, from the waist down, a squadron of jack-booted, goose-stepping marchers. Propped before this, leaning against the wall, is a wooden door on which there appears, in elegant script, a variety of fanciful descriptions for animal groupings: "a knot of toads," "a

duel of doves." The aural possibilities elicited here – the various noises of
large gatherings of like animals, the drumming of booted heels, the crash
of a door being kicked in – are sensually rich and diverse, yet ultimately
terrifying. Like the high, anxious whine of locusts in summer rut, it seethes
with the mindless force of the herd instinct run amok.

Truth © Annette Lemieux 1989
Courtesy The New Museum of Contemporary Art

Another, "Silencing Sound," is a large image of a mushroom cloud (the
one generated by the 1945 bombing of Nagasaki), to which 45 vintage snap-
shots have been glued, face down. What they are images of one cannot tell;
that is left to the viewer's speculation. The white squares and rectangles
formed by the backs of these little prints make a kind of checkerboard of
the image, blanking out parts of it; yet they, in turn, are wholly blanked out
by it, leaving only the merest trace, like those shadows of people etched by
atomic fire onto the walls of the bombed cities of Japan. Here the sounds
evoked are those of the people presumably in the photographs, the sound

of the blast and its aftermath, as well as the silence of those now-vanished victims of war.

A third piece, "Broken Parts," depicts a group of children with their ears pressed to the top of a grand piano; where the sheet music would normally lie before the pianist there is a pink rectangle with ear bones lightly drawn in pencil. Here again, a specific auditory experience is evoked. Yet the intended meaning of the piece does not come clear until one reads the catalogue and/or curator's note, which indicate that these are "deaf children learning to 'listen' by feeling the piano's vibrations."

Two other pieces in the installation – "Truth" and "Initial Sounds" – similarly require curatorial glosses to explain their content. The first of these, a formal portrait of Edgar Bergen and Charlie McCarthy, is overpainted with three rows of letters – representing, we learn elsewhere, the vowel sounds that ventriloquists initially practice. The second is a hear-no-evil/speak-no-evil/see-no-evil triptych overpainted with cyrillic lettering – which, the catalogue discloses, is an old Russian proverb that translates, "Eat bread and salt but speak the truth."

According to the critical apparatus for the show – Cahan's notes and Joseph Jacobs's catalogue essay – Lemieux is primarily concerned with deconstructing cultural power relationships. Certainly there is much evidence in the work on view to support this hypothesis. If so, it seems particularly odd, indeed hypocritical, for an artist with that commitment to produce work that requires the intervention of an intellectual priesthood to translate and deliver its message. It's as if a contemporary Protestant theologian had decided to write Biblical commentary in Latin. This is symptomatic of a notable tendency of artwork in our times: to be not only symbiotically entwined with critical/curatorial exegesis but to be parasitically dependent on it. It's regrettable to find this manifest in some of Lemieux's work, because at her best she creates complex, resonant structures of thought self-contained enough to communicate on their own, without benefit of clergy.

Letter from

Letter from: New York, No. 12

Cagey strategist and baseball aficionado that he is, John Szarkowski, in what is possibly the last inning of his curatorial career as head of the Department of Photography at the Museum of Modern Art, has chosen to throw a junk ball masquerading as a curve. Or vice versa. At least that's how this longtime observer reads "Photography Until Now," Szarkowski's version of the history of photography, which has just made its debut in both book and exhibition form under MoMA's auspices.

Coming as it does at the tail end of the world-wide sesquicentennial celebration of photography's public birth, the project – part of the MoMA series sponsored by Springs Industries, Inc. – can be seen as the Modern's renewed claim to authority as a source of substantial historianship in the medium. That claim was initially staked out in 1937, when Beaumont Newhall organized the museum's pioneering first survey of the history of photography, accompanying it with a catalogue that subsequently turned into a monograph. That volume, in its subsequent incarnations, became the standard reference in the field, essentially unchallenged for three decades and still the best-known (and best-selling) history of the medium in English.

Newhall's is a very readable tome. Essentially, it's the movie version of the history of photography, its final draft written with the guidance of a Hollywood screenwriter and "play doctor." Its biases and shortcomings are many, and serious; they have inspired at least two decades of revisionism. But it is a work based on seminal scholarship, which makes it still useful as a reference even though many of its author's opinions are long outdated.

Szarkowski's volume (Bulfinch Press/Little, Brown) is equally readable, but for another reason: it's genuinely well-written, perhaps more finely crafted as a piece of prose than any other work on this topic of comparable length in English. Elegance, verve, grace, wit, affection, and honed sarcasm are in evidence throughout. I absorbed it in one sitting, on a non-stop plane trip to California, which offers some index of its engagingness and entertainment value – and, perhaps, of its substance.

Artist Unknown, ca 1850
Museum of Modern Art, New York

For, although it is at its strongest in its discussion of 19th-century photography, this is not a work of scholarship. That comes as no surprise; his labors on the Eugène Atget archives aside, Szarkowski is not known as a scholar. Indeed, as if to make this point clear, no bibliography is included (though there are footnotes). Nor is it a major theoretical enterprise, despite its ostensible thesis that the medium's imagistic evolution has been determined largely by technological developments that were outside the control of most of its practitioners.

This is not a new idea, by any means, but I've rarely seen those changes during the medium's early years described so lucidly. Szarkowski's skill as

a writer and his craft experience as a photographer – for he was a working picture-maker when, as a dark-horse candidate, he was brought in to replace Edward Steichen in 1962 – meld marvelously in the passages which discuss the making of photographs. The inclusion of such objects as the steel gravure printing plate of a Charles Nègre study of Chartres alongside the ink print pulled therefrom, and a masked, retouched, annotated negative by Francis Frith, enrich one's sense of the physicality of photographic production. (Oddly, however, the curator offers no insight into, and only the slightest commentary on, the printmaking process as a crucial stage in the photographer's intepretative relationship to his/her negatives. And, save for some discussion of color photography, the technological thesis simply disappears from the discourse on work produced after World War II.)

This may not be scholarship, or original theory, but it is cogent, thoughtful, and thought-provoking. Unfortunately, running along with it on the same set of tracks are several other contenders for our attention. One of these is a set of decidedly eccentric opinions as to which photographers exemplify these issues and thus merit mention in such an account. Szarkowski is not so inclined as was Newhall to use his history as a vehicle on which to assemble his pantheon, but that may be because he's constructed it in previous shows – the four-part Atget project, the "New Documents" show of 1967, the Walker Evans and Diane Arbus and Garry Winogrand retrospectives, for example.

Many photographers are mentioned in this text, quite a few of them praisingly, most of them in passing. They are rarely linked directly to his technological thesis, and no supporting argument is ever offered for the curator's assessment of them; the judgement is simply asserted, in a word or short phrase, though usually in a cunning enough manner that the paean is made to seem modestly qualified and the evaluation a matter of wide and inarguable consensus. He achieves this by deploying such generalizations as "advanced photographers," "photographers of ambition and high talent," and such. This is Szarkowski at his most clever and manipulative – which, to my way of thinking, is at his weakest.

Here the work degenerates into connoisseurship – or, more precisely, taste-mongering. Connoisseurship, after all, despite the bad rap it's received

in recent years, implies first-hand knowledge of the work in question and the ability to discuss its specific, unique qualities. But Szarkowski indulges himself here in what I would have to call minimalist or conceptual connoisseurship; he actually has little to say about most of the bodies of work he mentions and nothing particular to say about any of the pictures, though he does make clear by innuendo what he favors and what he loathes, the latter category including almost everything produced since 1960.

Which brings us to the pictures. A history of a visual medium is usually a rationale for some selection of representative images. But why this set was picked mystifies me, even after reading the book; it will surely confound those who encounter the exhibit first, since the show's wall texts are much briefer and make no reference to any of the images. For here we have a survey that presumably updates the Newhall project yet includes five images each by Paul Martin, Charles Marville and William Henry Fox Talbot but only one by Robert Frank, Diane Arbus, Roy DeCarava and Manuel Alvarez Bravo; four apiece by Edward Steichen and Charles Nègre, yet none by Ralph Gibson, Lee Miller, Eikoh Hosoe, Carlotta Corpron, Duane Michals, Marion Palfi, Les Krims, Mary Ellen Mark, Larry Clark or Eugene Richards.

No less notably, the anonymous photographer who described the Krupp Steel Works in Germany in the early 1900s is better represented than any of those whom Szarkowski has sponsored in solo shows over the years – save for Lee Friedlander, whose self-portrait is the book's frontispiece and whose book *The American Monument* is on display, open to a multi-image layout. (Friedlander is also hailed as the producer of the era's most important photographic bookworks.) The curator's lack of interest in or active distaste for most photography produced during his tenure at the museum is palpable.

Out of more than 180 photographers represented, only sixteen are women, only one is black; after 1950, almost all are North American. Of the almost 300 images, over one-quarter are by photographers either literally anonymous or virtually so, leaving us with only single images by which to gauge them. I could go on with such statistics, as I'm sure others will.

There are certainly pleasures to be found in the text, and many more to be found in the images, including such finds from the past as Jane Clifford's beautifully-lit and finely observed "Shield" from the 1860s, Pierre-Charles

Simart's close-up of tree branches from the preceding decade, and the anonymous "stilled life" of a bird transfixed by an arrow from about the same time. Szarkowski has a good eye, though in connoisseurship as in picture-making that quality is only a starting point. But what is most keenly manifest here is an exhaustion, even an ennui, along with an abdication of responsibility.

Even if – especially if – this show is, as some have suggested, Szarkowski's curatorial swan song, he owes his profession that closely reasoned and buttressed argument that presumably connects the lineage he's promoted all these years: Atget to Evans through Frank to Arbus, Friedlander and Winogrand. He's made clear his preference for imagery which privileges the semantics over the poetics, and has intimated that there is a system for uncovering a poetics within those semantics. This present project was the occasion on which he could rightly be expected to make his case – to put up or shut up. But Szarkowski's heart is no longer in the game. So what we're offered instead is merely a set of pictures John Szarkowski likes – a comparative *bagatelle* which even he has taken to describing (on a recent NPR program) as a kind of freeform experiment in process whose outcome he could not foresee. Such a misuse of power, prestige and influence is an effective if lamentable indication of why the Modern's credibility and influence on the medium have waned so dramatically during the last decade of his tenure.

Fortunately for those who will carry on the work elsewhere, it will be far easier to deconstruct (even, I regret to say, disregard) Szarkowski's history than it was Newhall's, because this project makes no significant research contribution to the medium's historiography that requires disentangling from its prejudices. Perhaps, too (and I do not say this to excuse its deficiencies), this enterprise was doomed from the very start. It's now obvious that photography is a complex phenomenon, and a global one, multinational, multicultural – so much so that we've clearly reached the end of the era of unified-field theories and synoptic surveys of the entire medium. The Museum of Modern Art published what was really the first North American attempt at a comprehensive single-volume history of photography. Let us hope that it has now published the last.

Letter from: New York, No. 13

In 1950, at the age of 50, Pierre Molinier, a reclusive, accomplished but minor French painter, experimented for the first time with photography. Not long thereafter he began working directorially, staging for his camera events in which he appeared disguised as a hermaphrodite and/or a woman. These scenarios became elaborate, involving props, costumes, makeup, models and a plaster mannequin. As the pictures grew more complex and improbable they often became explicitly erotic, exemplifying what Freud called the "polymorphous perverse." Molinier's technical repertoire evolved to include double exposure, deft, sophisticated photocollage and retouching, so that his fantastic illusions would be as credible as possible.

The work revolves around several themes, often intermixed – autobiography, self-portraiture, transvestism and transsexuality, bondage and voyeurism among them. His flair for the *mise-en-scene* is consistent, and he frequently employs vignetting to create the effect of peering through a spyhole. Many of the images are variations on particular motifs, yet the sporadic and incomplete selections that have been published to date do not indicate how, if at all, Molinier himself organized his output.

Only one book – *Pierre Molinier, Lui-Même,* issued in Munich in 1972 – proposes a clear structure; it begins with images portraying Molinier's own death and the departure of his soul from his body, and then proceeds to explore systematically the complexities of his sexual persona. For the first image in this sequence the artist created his own grave, strewn with autumn leaves, marked with a cross on which is inscribed the following: "Here lies Pierre Molinier, born April 13, 1900, died around 1950. He was a man

without morality; he despised glory and honor. Useless to pray for him." In 1976 he put the barrel of a pistol into his mouth and pulled the trigger.

All this would be of little more than clinical interest had Molinier been only another person acting out an obsession before a camera. Troublingly, however, Molinier – like the even less well-known German, Tilo Keil – was a maker of imagery remarkable not only for its literal subject matter but for the idiosyncratic vision, authoritative style and (in Molinier's case) superb craft which renders its presentation both convincing and engrossing.

What resulted from Molinier's investigations was a unique body of work whose size is still undetermined but which certainly encompasses several hundred images. (By 1967 he was devoting his efforts as an artist exclusively to photography.) No comprehensive catalogue has yet been produced, though his work has found a wide audience in Europe and several small volumes of his imagery have been published there over the past two decades. To date, nothing has appeared in print in this country, and indeed the very first US showing of his work just took place at Brent Sikkema Fine Art.

The show comprised 25 of Molinier's small black & white prints on the walls, with another five available for viewing. All were undated, but can be presumed to date somewhere between 1960–76. Many – like the acrobatic epitomization of *amour-propre*, "Autofellation" – have never been published. It was a random grouping, yet this cross-section provided an adequate introduction to his several approaches to his themes. One could see from them what he took from the eccentric pictorialist William Mortensen, what he shared with the similarly obsessed surrealist Hans Bellmer, and the ways in which he served as a precursor of (and, in some cases, a direct influence on) Joel-Peter Witkin, Lucas Samaras, Helmut Newton, and Guy Bourdin.

In him we have perhaps our most extreme example of photography as the instrument for manifesting and examining the complexities of sexual identity, uninhibited by taboo and unconfined by closet or darkroom. Moreover, he was not merely voicing private concerns, but was addressing an audience; he obviously intended his imagery to enter the arena of public discourse, and achieved that during his lifetime. At a moment when the sexuality of older people and the social construction of gender identity are hot topics, Molinier's work seems increasingly prophetic and germane.

Letter from: Arles, No. 17

"Flat" is the word everyone seems to be using to describe this year's Arles festival, the main stretch of which took place from July 6–11. A curious adjective to spring spontaneously to the lips of a dozen far-flung witnesses, but appropriate for an event that had no notable peaks or troughs.

Perhaps this was simply the inevitable letdown after the extraordinary attention lavished on last year's gathering, which celebrated the 20th anniversary of the Rencontres Internationales de la Photographie (as the festival is formally known). Alternately, one could write it off as the last earnest effort of an outgoing interim administration, more concerned with holding a leaky vessel together than with securing the cargo. Maybe it was both, in combination with the fact that the Rencontres is getting old and not doing much to keep itself in shape. Regardless of the cause to which one attributes the results, the fact is that this year's RIP was something no festival can afford to be more than one time in a row: dull.

Jean-Luc Monterosso of Paris Audio-Visuel, which organizes the biennial "Mois de la Photo" in Paris (the next edition of which is upcoming in November) issued a challenge to the field last spring in the announcement of the forthcoming version of the "Mois." Outlining its three themes as *Japan, social discourse* and *theater and spectacle*, Monterosso claimed to be "laying the foundations of a new school of vision" for the biennale he heads – and, implicitly, for those others that have begun to function cooperatively with it. "The moment has come," he wrote, "to abandon the temptation of presenting a disparate panorama of events and to install a methodical approach respecting the fundamental rules of a means of artistic expression which is

credited today with a philosophy and a past, as was the case with cinema after the war ... In other words, the popular idea of shock and surprise that is so sought after in festivals and events these days has given way to a calmer form of investigation: the visitor's path through the Month of Photography 90 appears to be more of a reconnaissance mission than a marathon of images ... [T]his search for precision and coherence is now even more essential."

It remains to be seen whether this fall's offering in Paris will live up to those standards. Nonetheless, a gauntlet has clearly been flung down, for what Monterosso is reacting against in his pithy polemic is the boilerplate version of the international photo festival that's sprung up everywhere over the past ten or so years – for which Arles, as the oldest, has generally been the model.

That's why, at the lavish press lunch sponsored by Kodak toward the end of the Rencontres, I decided to chew on the hand that had just fed me. Kodak has become inarguably the main corporate sponsor of the Rencontres, and Ray de Moulin, who supervises Kodak's involvement in the festival, had taken the stage between courses to field queries. Manifesting demonstrably poor judgment, a Kodak press rep thrust a microphone into my face and asked me to start off the questions. So, tactfully, I paraphrased Monterosso's challenge and asked de Moulin how it pertained to the Rencontres.

To his credit, he did not beat around the bush. The essence of his response: Let Arles be Arles. Every event has to find its own unique identity; those that have tried to imitate the ambiance of Arles – here he paused to single out Houston FotoFest and the International Photography Congress in Maine – have failed dismally in that regard. A coherent, thematic structure might work somewhere else, but not here. Arles may be pointless and shapeless, but we like it that way; it's a terrific site and a great occasion for networking. Next question.

With that as the attitude of its principal backer, the Rencontres is not likely to change. I think that spells trouble. Not for Kodak, which can simply take its sponsorship elsewhere if Arles loses its glow, but for the Rencontres (not to mention the town itself, whose economy has become deeply dependent on Rencontres-generated revenue). If the Rencontres' function in

the field is restricted to being a locus for interchange, then its quality will depend not on what it presents but rather on who it attracts. What happens if you give a networking party and nobody comes?

Though the ambiance of the Place du Forum is undeniable, it's clearly not irresistible; a great many familiar faces were absent this year from those café tables – and their seats were not filled by replacements. Wherever the action was, it was elsewhere. Once upon a time, the European photography community flocked to Arles not only because it was energized but because they had no place else to go. Now there's a full menu of alternatives from which to choose. The fact is that, from now on, Arles will have to earn its audience; if it merely coasts on its longevity and rests on its laurels, it will inevitably watch itself decline....

To give you an idea of what's currently considered to be an organizing principle, this year's "theme" was "History/histories," a catch-phrase amorphous enough to cover just about anything. This year's logo – to be found on all the literature, as well as the souvenir posters, T-shirts, and playing cards (yes, playing cards) on sale at RIP headquarters – was derived from Frantisek Drtikol's image of a nude woman running along the crest of an arched ramp. Manifestly irrelevant to the theme, this blithe spirit on the brink of an imminent downward plunge was certainly an odd choice of symbol to represent this juncture of the Rencontres' own history.

As for the exhibitions, there was a general sense of heedlessness and a surprising amount of junk, even for Arles. For example, I never thought I'd see a Man Ray show that I found actually dreadful, but "Man Ray: Behind the Facade" disabused me of that assumption. This was an endless exhibit of what were clearly nothing more than early architectural studies and landscape record shots – bottom-drawer stuff that he'd kept in a scrapbook, apparently intended as nothing more than note-taking. So far as I know, only one of these was ever shown or published in his lifetime. Looting a photographer's rejects in this fashion, and presenting the work as if he'd approved it for exhibition, is the art-historical equivalent of graverobbing.

This was one of three shows presented under the rubric "Photography Is Not Art." The other two were surveys of work from the '20s by the Bel-

Untitled, Nikola Vuco 1926
Museum of Applied Arts, Belgrade

gian Willy Kessels – a 70-print retrospective – and the Yugoslavian Nikola
Vuco, represented by two dozen images.... The Vuco sampling was also one
of several exhibits at Arles that addressed eastern Europe. Others included
a one-man show by the Lithuanian Aleksandras Macijauskas and a group
show of contemporary Lithuanian photography, the most impressive of
which was the work of Buduytis; he makes powerful studies of people in
jail and/or mental institutions, whose intensity he undermines unaccountably
by hand-coloring the black & white prints. In another solo show, Juozas

Kazlauskas presented a powerful document of a 1989 group pilgrimage to a Stalinist labor camp where, by official count, 2000 Lithuanians perished. Several strong presences were manifested in a 120-print survey of work by young Czechs: Tono Stano was represented by strong portraits made in collaboration with Gabina Farova; Pavel Banka, whose work has been seen here at Houston FotoFest, offered more of his cryptic, hand-colored staged events; there was a remarkable set of large, dark, blurred faces printed on cloths that fluttered loosely against the wall, by Pavel Mara; and I'm more convinced than ever that some smart American publisher is going to snap up Miro Svolik and produce his sequences as books for what are sometimes referred to as "children of all ages."

...In conjunction with this focus on the east, Magnum, the picture agency, put together what could have been a most provocative group show of photographs its members have made in eastern Europe. Its title translates as "Histories of the East, 1945–1990: Travels in Forgotten Europe." This 120-print show sprawled through the Bourse du Travail, the local union hall. It was an intriguing setting, given that Arles until recently had a pro-communist population and a largely communist government (the town was a jumping-off point for anti-fascist volunteers like the Lincoln Brigade during the Spanish Civil War). According to photojournalist Susan Meiselas, the show provoked lots of dialogue both within the union and between the union and the agency, which initiated the proposal to mount it in that space. But the absence of anything more than minimal caption information – only date and place, usually – decontextualized the imagery more than any newspaper or magazine would have done, thus minimizing its informational value.

In fact, most of the shows I saw were marred by the absence of adequate captioning and the frequent lack of even the most minimal wall labels and other explanatory texts. This failure to annotate and contextualize is not only endemic to the RIP, where it's virtually a tradition by now, but has become pandemic among the international festivals. Yet, if their frequently-claimed educational motives are genuine, this grievous lack of even rudimentary critical, historical and curatorial commentary at these expositions is a serious shortcoming, all the more so because it's rectifiable. I'd strongly

Letter from

advise Louis Mesplé, the Rencontres' new director, to take the funds and energies expended on producing just one of the lavish evening slide presentations and redirect them towards this end. And I'd recommend that all directors of all such festivals prioritize such contextualization over the standard pictures-by-the-yard approach. Photography, photographers, and the medium's audience would be better served by far....

Richard Misrach's "The Pit" was one of the two exhibits I saw there that hit me the hardest. For close to a decade Misrach has been working on his "Desert Cantos," a set of suites that – perhaps taking a cue from Pound – ramble through various aspects of their subject: human impact on the deserts of the American southwest. For the most part, he has maintained a posture of neutrality, whether facing nuclear test sites, military target ranges, or desert fires. But then he plunged into the pits in which Nevada's farmers dump the still-births, mutant offspring and unexplained deaths from their livestock – most of them attributable (though the government vehemently denies it) to radioactive fallout from atmospheric testing.

The consequent series, "Canto VI/The Pit," is something out of Bosch or Goya; the imagery's sensuality, detail and formal intelligence are used to point up the monstrosity of what it describes. Because Misrach works with a large-format camera and makes big color prints – these were 30x40 inches – he spares the viewer nothing. These grim, elegiac pictures, which form the moral epicenter of Misrach's project, were installed, appropriately enough, in a once-sacral space: a high-ceilinged room in what was the palace of the region's archbishop. Even in that cool stone chamber, the sound and smell of these photographs quickly became unbearable. If there were a hell for animals, it might well look like this.

And, on a different emotional wavelength, there was "Seductive Woman, Femme Fatale," another of the eastern European entries, in which curator Alain Sayag paired the Czechs Drtikol and Jan Saudek – an odd yet most compatible combination.... I'm not sure Sayag's title really fit the work – there's too much tender, melancholic fatalism in both œuvres to suit those words well. But the parallels between them suggested an intergenerational continuity in Czech photography that would be exciting to explore further.

Thoughtful shows like this one, and polemics like the Misrach installation, should be norms, not exceptions, at an international festival like the RIP. For the context in which this gathering takes place is undergoing dramatic change. Over the next decade it seems likely that the world will continue to shrink, the boundaries between nations will continue to dissolve, the global archives will disgorge a continuing stream of new, recent, and old pictures, and the technology for image generation, storage, retrieval and display will become ever more complex, frustrating and exciting.

It may be that, amidst all that uproar, the international image community will want a low-key, low-tech watering hole at which to party down – and will allow Arles to fill that niche. But maybe not. Maybe, greedy (and industrious) sorts that we are, we'll gravitate instead to festivals that offer meticulously-planned, carefully-wrought, substantial exhibits and presentations along with the parties and schmoozing. And, in any case, our selfish desires as short-term visitors notwithstanding, if the town has any say in its own future, why should it settle for being photography's version of Fort Lauderdale?

Maybe it's time for Arles itself to plan its own future in relation to the medium. The questions that should be asked today are these: What will draw the international photography community to Arles in 2001? What needs to be initiated now in order to ensure that eventuality? And is this truly what the Arlesians want? After all, Arles is a place with a rich history that goes back two thousand years; the RIP, its offspring, has turned 21 and, having reached its majority, can now be held responsible for its own actions – or be asked to leave home.

Letter from

Letter from: Philadelphia/New York, No. 18

When it was first published in 1971, Larry Clark's *Tulsa* came as a bomb-shell. This book, the first photographic account of the emerging drug culture by a participant in the scene, was a raw, blunt, unsparing scrutiny of addiction, alienation and violence in the heartlands. The book shocked many, for various reasons. This was no decadent coastal Gomorrah, after all, it was Oklahoma, where the wind comes sweeping down the plain. And these weren't goofy, blissful hippies, but wired middle- and working-class kids who carried guns, beat each other bloody, fought with the cops, did time in jail, and sometimes died.

Clark, who acknowledged his own addiction to amphetamines on the volume's first page, grew up in the scene, an unhappy kid whose hobby, photography, was so taken for granted by his friends that the presence of his camera went unquestioned in even the most harrowing and intimate of circumstances: the thrashing of an informer, the treatment of an accidental gunshot wound, a prostitute introducing a teenager to oral sex – even a pregnant girl shooting up.

Whatever his emotional problems, Clark was a gifted young photographer who'd taken as his models the two greatest living exemplars of photographic anomie, Robert Frank and W. Eugene Smith. His image structures and print-ing style owed more to Frank, but he shared Smith's empathic capacity and inclination to burrow into situations, to photograph from within. Or, at least, he had *carte blanche* to do so in this situation, and used his opportunity well.

Bouncing around the country, in and out of trouble with the law, Clark eventually crossed paths with photographer Ralph Gibson, who helped him

pull the material into book form and then published it himself in the small, germinal line of experimental photo books – his own and some key works by others – that he'd begun to issue under the Lustrum Press imprint. An instant success, the thin, tight, cleanly edited book made Clark's reputation overnight; it was at once an important social document, a brutally frank personal testament, and a brilliant exploration of book form. As a result of the acclaim, Clark lectured and exhibited widely; the book, quickly acknowledged as a classic, sold well for a small-press venture, and would have gone into at least a second printing.

But the grandparents of an infant shown dead in one of the images, grieving and angry, initiated a suit for invasion of privacy, and the book went out of print instead. Copies of the original edition became scarce as hen's teeth; within a few years they were selling for hundreds of dollars. Clark ended up in trouble, did time in jail, then got out and slowly rebuilt his life. He issued a reprint of *Tulsa* himself, risking the lawsuit (which never came), began photographing the teenage runaways on 42nd Street, and eventually put together a rambling, scrapbook-like volume he called *Teenage Lust*, which he also published himself after a major photographic house turned it down, afraid of its explicitness.

Formally speaking, *Teenage Lust* bears the same relationship to *Tulsa* that Robert Frank's *The Lines of My Hand* does to his own earlier, seminal work, *The Americans*. Both photographers' later volumes reconsider and recontextualize their earlier achievements, embedding them more explicitly in autobiographical settings. It's a fascinating process to watch, not unlike Walt Whitman's re-editings of *Leaves of Grass*. In Frank's case, it worked; though not as germinal as *The Americans*, the later volume is a powerful work that can stand on its own. Clark did not achieve that with *Teenage Lust*, perhaps because – as the long, transcribed interview that concludes it makes clear – he hadn't come to understand himself much better than he did during his speed-freak days.

Now he's offering up yet another re-engagement with this same material, in the form of an installation at Luhring Augustine. Consisting of 50 black & white prints, mostly from *Tulsa* and *Teenage Lust*, plus 12 photocollages and assemblages and a laser-disk video piece, this is a most peculiar show.

Letter from

One of its strangest aspects – given the fact that the bulk of the imagery is quite familiar – is the sense of work-in-progress, of psychological undigestedness, that it exudes.

The new works are not particularly interesting as objects to look at – Clark will not give Hannah Höch or Romare Bearden a run for their money. Having the general appearance of bulletin boards, they're more akin to literature: they ask to be browsed through and read. What they yield is a free-associative, stream-of-consciousness flow in which Satanism, homoeroticism, patricide, matricide, teen suicide, rape, child abuse, drug abuse, rock and roll and television stew about in a murky subtext.

Those photographs of Clark's included in these pieces – one of which is as large as 42×87 inches – are mostly perfunctory sx-70s shot off the TV screen; the subjects, invariably, are teenage boys. They include teen idols Corey Haim, Jay Ferguson and Matt Dillon, who are regularly juxtaposed to the anonymous young male hustlers Clark has been photographing on the Deuce. Some connection between them is certainly implied – as is some relationship between Elvis Presley, the Rolling Stones, Hollywood, and Bill, the otherwise unidentified teen wrestler whose brief interview with Bryant Gumbel repeats endlessly on the video monitor in the gallery's front room.

A psychiatrist would no doubt be inclined to speculate that Clark is grappling here with some personal demons – traumas both familial and sexual – that he has yet to exorcise. The newspaper accounts of crimes by teenagers that are a connective thread in the new pieces make frequent references to the adolescents' need for love, search for love, and lack of parental love; photocopies of two pages of an enraged, accusatory letter on that theme, from Clark to his own father, included in one collage, give that issue an autobiographical resonance in this setting. And while the adolescent male bonding that is central to *Tulsa* and *Teenage Lust* is overtly heterosexual and macho, its potentially homoerotic aspects become pronounced when those same images are positioned here alongside the portraits of male starlets and street hustlers; the inclusion of a plethora of phalluses, most of them displayed for Clark's camera by the "chickens" of Times Square, seems deliberately intended to raise this question.

Alternately, a strictly sociological reading would conclude that Clark is seeking to delineate – or at least to imply – causal connections between Hollywood teen fantasies, the deterioration of the nuclear family, devil worship, sexual disturbance, and other social ills on a grand scale. But that doesn't sound much like Clark, whose work, however uneven, has always particularized people rather than generalizing about them.

Whichever is the case, the new pieces – and the installation as a whole – fail to articulate whatever's on Clark's mind and/or conscience. Who is he accusing, and of what? What is he confessing, and to whom? These unresolved works are highly charged, but inarticulate; full of barely repressed rage and blamefulness, they don't make clear what – or who – their target might be. They neither illuminate nor are illuminated by his earlier projects. For all their earnestness, they lack both direction and conviction, a problem that's plagued Clark's work from *Tulsa* on. Aside from his indictment of his father – who surely can't be blamed for all the horror Clark has collected into these dossiers – he refrains from stating his case and naming names. Perhaps he suspects that one of them might be his own.

Letter from: Lausanne, No. 19

...*Late last winter,* the Musée de l'Elysée in Lausanne, Switzerland, set in motion an ambitious project: a massive survey of eastern European photography. Though it made its debut only in 1985, the Musée has already become a force to be reckoned with on the European photography scene. Directed by Charles-Henri Favrod (who, among other achievements, produced Marcel Ophuls's film, *The Sorrow and the Pity*), the Musée is a regionally-sponsored institution with international aspirations. Its diversified exhibitions, most of which it originates in-house, travel throughout Europe; it has a strong publications program and an extensive line of postcards and posters. Many people swear by it, but I've heard a few swear at it as well.

...Whereas Switzerland's national museums are empowered to make their exhibition commitments autonomously, cantonal institutions like the Musée must have all their decisions individually approved by their cantonal government. Democratic in principle, this policy is cumbersome in practice; every plan, contract and payment requires negotiation between the Musée and its source of funds, which usually involves months and sometimes takes years. Thus, while the Musée's small staff permits flexibility and rapid decision-making, the sponsorial superstructure pulls the other way.

This preamble is necessary so that what the Musée attempted can be understood in perspective. Briefly put, sometime last February its director and staff determined that by mid-June, with the help of some outside advisors, they would organize and mount a 2000-print survey of eastern European photography by some 100 photographers, coordinate a concurrent meeting in Lausanne of some 60 of those photographers, initiate a traveling exhibi-

tion and catalogue based on all this activity – and run this enterprise through and around the cantonal political and administrative structure whose imprimatur it would require. It was a situation rife with crisis, and prone to crisis management. The Musée's staff plunged into this project wholeheartedly – leaving many prior commitments hanging fire or broken.... [T]hey were forced to operate so precipitously that what should have been key pieces of this project – the traveling version of the exhibit, an accompanying publication, press coverage from outside western Europe – were not put in place. Given the time frame, getting the work and the photographers to Lausanne became the project, at least in its first phase.

This the Musée accomplished; by my lights, they did it well. One result was to introduce into the current international dialogue on and around photography 100 bodies of work, most of them new to western eyes, representing nine nations from whose citizenry we've seen precious little photographic imagery in this century. (In the final tally there were three dozen Czechs; a dozen or more from Poland, Hungary, Lithuania, and what was then still called East Germany; and smaller numbers of Russians, Bulgarians, Ukrainians and Romanians.) Another consequence, not coincidental by any means, was to establish the Musée as the preeminent western European sponsor of eastern European photography.

To my surprise, I found myself the only North American journalist in attendance for the first week of the exhibit's run, during which the gathering of eastern European photographers also took place. I've visited the Soviet Union twice, in 1964 and 1988; and, for reasons too complex to go into here, spent a good bit of my childhood and adolescence among eastern-bloc scientists and diplomats visiting the United States. But I've had no professional interaction with the eastern European photography scene, so this was as new to me as it was to them.

What did I learn? Well, while East may be East and West West, the twain is certainly meeting – yet they are barely on speaking terms, even with themselves. The Musée's administration had assumed, somewhat naively, that these photographers had so much in common, including language, that it was only necessary to put them together in the same room to instigate dialogue. Toward that end a common dining tent was set up on the hillside,

everyone was issued meal tickets – and the photographers instantly Balkan-ized themselves. The Bulgarians sat with the Bulgarians, the Romanians with the Romanians, the Poles with the Poles. Moreover, since Russian is the mother tongue only of Russians, everyone else refused to speak it on prin-ciple – instead communicating with those from other nations in halting French, German, English and other tongues.

So far as I could tell from eavesdropping, suspicion was the dominant mood of these encounters. For my part, even after a formal introduction by Favrod himself I could find hardly anyone interested in talking with a critic from the US about anything – their own work, the photo scene in their country, photography in the States, theory, history. It wasn't the language barrier. Partly it may have been the fact that there's really no such thing as a professional photo critic in eastern Europe. But mostly it seemed to be a matter of elementary distrust of speaking to strangers, since you never know who they might be. (Under the circumstances, I decided to refrain from disclosing the CIA infiltration of the US gallery/museum circuit.)

…The Musée did everything it could to alleviate such anxieties – speak-ing frankly with the photographers, calling an open meeting to discuss the policies and practices that had regulated the project, offering equal sums for the purchase of work towards the traveling version of the show. For that matter, the show itself was mounted not at the Musée but at the Palais de Beaulieu, a convention center and trade-fair site across town. Like Rex Stout's obese detective, Nero Wolfe, who requires everyone entering his office to sit because he "prefers eyes at a level," the Musée thereby elimi-nated an inevitable flood of complaints about favoritism by putting all the images on identical modular panels in the same large space.

As for the show, "One Hundred Photographers from the East," its major fault – overwhelming size – was also one of its virtues, and part of its very premise. My own two visits were not nearly sufficient to encompass it, and I doubt that most attendees spent as much time with it as I did. What, then, was the purpose of operating on this scale – especially since no catalogue recording the entirety of this version of the show will ever be available, and the traveling version of the exhibit will necessarily be much smaller? Was it to please the photographers, or to send back to their homelands the message

that they and their work were valued? Was it simply to benefit the Lausanne audience and those in the field who, like me, managed to get ourselves there? Might it not have made more sense to do the show in two installments, or to do a smaller exhibit and put more effort into parallel activities such as documentation?

Such a critique – which boils down to "more food than I could eat, and no doggie bags" – ultimately sounds ungracious when one considers the lavishness and substantiality of the feast. After all, here was a rare chance to consider eastern European photography as a whole, and even to compare it with western European photography of eastern Europe: "An Atmosphere of Liberty," a concurrent show of work by 17 photographers associated with the French journal *Libération* and the French picture agency VU, was mounted nearby, at the lakeside Theatre de Vidy.

While I can claim to have seen it all, I certainly have not absorbed it, even six months later – which is why this account is so tardy. Nor am I in a position to certify that what I saw was comprehensive, or truly representative, though I heard no complaints from knowledgeable eastern or western European photographers, curators and historians about major biases and omissions, aside from a few caused by political and/or logistical problems the Musée was unable to resolve in time for the opening.

Some general impressions: the Czechs are the freest, the Bulgarians the most morose, the Romanians the least accomplished technically. Specific subject matter aside, the primary difference between eastern European photography and imagery from the West and Japan is that most of it is still black & white; I'd estimate that less than ten per cent of these works were in color, a remarkable statistic for a massive show of primarily contemporary photography. "Straight," documentary and photojournalistic attitudes are still prevalent, but directorial imagery, process experimentation, mixed-media work and virtually all other forms of current photographic inquiry are under exploration as well.

During my last visit to the Soviet Union, I found myself feeling often as though I were walking among an entire population that had awakened one morning to find itself in the psychoanalytic condition of analysands whose most buried secrets had suddenly become available to themselves as the

doors of repressed memory were finally forced open. This show bore out that intuition, for as a totality it felt healing yet haunted: by Stalinism, by Nazism, by anti-Semitism. As a nexus for those forces of darkness, World War II still shapes the youth of eastern Europe, in ways that their US counterparts, oblivious even to the Vietnam War, cannot begin to comprehend.

In fact, the show opened with Gottfried Hellnwein's "Selektion," a memorial to Kristallnacht: 16 enormous laser-scanned color portraits of cadaverous-looking children, eyes closed, faces coated with white powder. Mounted outside the Palais de Beaulieu, they greeted visitors from across the plaza. As one got closer, one could see horizontal cuts across the bottom of each; some unnamed person had systematically slashed the throats of these images when the installation was first mounted in Cologne.

This elegiac mood was one of the show's diegeses, a thread connecting the East German Richard Peter's grisly reportage of Dresden after the February 1945 bombing with the enlarged contact strips – 15 images in all – showing the consummation by fire of the steeple of St. Peter's Church in Riga as the result of German bombing on June 29, 1941, by Vilis Ridzenieks of Lithuania; linking the Russian Aljona Frankl's black and white documentation of the present-day Jewish community of Budapest and Tomasz Tomaszewski's color studies of Polish Jewry with the retrospective photomontage meditation "Time in Auschwitz" by Waldemar Jama of Poland and Benedykt Jerzy Dorys's never-before-seen account of shtetl life in Kazimierz and Wisla, Poland, in the years 1931–32; binding the Pole Wieslaw Vistan Brzoska's installation, "Entropy" – a darkened space containing semi-eradicated images of faces on its walls, low platforms with the outlines of bare feet on the floor, piles of old shoes and valises, and a dusty view camera on a tripod, evoking some departure point for parts unknown – with the official portraits of anonymous consignees to the gulags; and merging Bernard Grzywacz's three dozen 1950s Leica snapshots of Vorkuta, the gulag in which he was incarcerated, with Tomasz Kizny's "rephotography" of that hellhole from earlier this year.

This commemorative impulse could be found elsewhere in the show as well. There were the image-text pieces of Modris Rubenis of Lithuania, portraits of people created by layering snapshots and old letters; his countryman Egon Spuris's bleak, gritty studies of the workers' quarters of Riga,

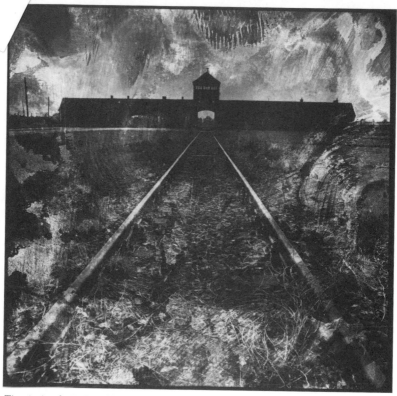

Time in Auschwitz © Waldemar Jama
Courtesy of the Artist

constructed in the 19th century; and the too-brief selection from Sandor Kardos's obsessive one-man operation, the "Horus Archives," a repository for found images of Hungarian life – mostly amateur snapshots – with which Kardos is constructing a vernacular history of his nation in a venture directly related to Dave Heath's "Un Grand Album Ordinaire" and the curatorial experiments of Paul Vanderbilt.

This is not to say that all eastern European photographers are trapped in the past; for example, little of this intruded directly into the 15-print retro-

Letter from

spective devoted to Edward Hartwig's work between 1928 and 1989. Hartwig, born in Moscow in 1909, now lives in Warsaw; his relation to that city might be likened to Joseph Sudek's with Prague, for, like Sudek, Hartwig explored all modes of black and white experimentation from pictorialism to modernism.

There was wit and humor to be found, in the droll fantasies of Czechoslovakia's Miro Svolik and the fey Duane Michals-influenced image-text sequences of Mariusz Hermanowicz, a Polish expatriate now living in France. Playfulness and testing of the potentials of the medium's materials manifested themselves in work from Hungary (Agnes Eperjesi's exploration of selective development and painting with developer, Istvan Halas's montages and solarizations), Czechoslovakia (Kamil Varga's tableaux with added light drawing à la Barbara Morgan), Poland (Krzysztof Pruszkowski's in-camera multiple exposures in which dozens of variants on the same subject – Warsawites waiting on line for bread; tombstones in Warsaw's Jewish cemetery – are superimposed onto each other, like a pre-digital Nancy Burson), and elsewhere. There was formalism from Poland's Krzystof Cichosz and Hungary's Gabor Medvigy; minimalism from "Anonymous of Prague," two collaborators whose installation consisted of grainy street-level panoramas of storefront; conceptualism from Poland's Zbigniew Tomaszczuk ("Leçon d'Esthetique," 1987, in which 5 scenes are shown with and without the presence of the photographer and his family) and East Germany's Michael Sheffer (an enigmatic installation titled "For Kurt, 1987–1990"); and even postmodernism (in Cibachrome, no less) by the Czech Pavel Mara.

Yet it all seemed informed by pain: the pain of the distant past, of the recent past, of the present – even the anticipated pain of the difficult immediate future. Medvigy's Siskind-like abstractions were patterns found in highly carcinogenic soot that fell on Budapest in 1989; Cichosz's seemingly subjectless scratched and mutilated surfaces resolved into portraits of people who have "disappeared."

If this sense of struggle could be felt underlying even the most formally radical work, it was visibly manifest in the reportage and documentary imagery: Pavel Nadvornik's confrontational, interrogative 12-print suite on the transvestites of Prague; Joseph Koudelka's 1960s visions of gypsy life

and images of "Prague Spring"; Lenke Szilagyi's odd, sad glimpses of women and children; Pavel Stecha's images from a ward for alcoholics, their faces in his large black and white prints splashed with blood-like red enamel paint; Sergei Podlesnov's gripping, world-class photojournalism from crises in Armenia, Afghanistan and elsewhere; Gerhard Kiesling's traditional but evocative project on the working lives of East German miners; Emilian Savescu's "Night of December 21 and after," concerning last year's events in Romania; Wilhelm Mikhailovsky's "Condemned to Death," a bookwork that follows a petty criminal from trial to death row; Stanislaw Markowski's extensive coverage of strikes and street actions in Czechoslovakia dating back to 1981, done with an eye for the telling detail and the intimate moment in a public event; Garo Keshishian's tough studies of Bulgarian forced-labor conscripts.

To be sure, much of all this work – little of which has been seen in the West, and some of which has never been exhibited before – was celebratory. But if there was exultation here, it was a joy earned through suffering, flavored with rage. I was reminded of the creature in the desert Stephen Crane comes across in one of his poems, eating his own heart, relishing it "Because it is bitter/And because it is my heart." In the end, I found myself thinking that most of us in the West – even eastern Europeans – simply have no idea of what it has meant to be eastern European in this century, for even those who lived there are only now able to acknowledge it. There's a long period of reeducation ahead for all of us; and the paper trail we'll have to follow is strewn not only with sheets bearing the written word but with photographs of all kinds, like these.

Compared to the probing, in-depth examinations that the eastern European photographers had achieved in their documentary projects, most of what was presented in the *Libération*/Agence VU exhibit– by such as Leonard Freed, John Vink, Raymond Depardon and Didier Lefevre – seemed sympathetic but superficial. An exception was Carl de Keyzer's "Homo Sovieticus," 70 black & white prints from large-format and panoramic negatives produced in the USSR during 1988–89. Mostly addressing people at leisure or at play, at public festivities or celebrations, these sumptuous prints of densely-layered images scrutinized dress, gesture, social interaction and the function of visual images as mnemonic training devices in totalitarian cul-

Letter from

tures. Intelligent as sociology and powerful (though uneven) as imagery, this show occupied the entire upper floor at the Theatre de Vidy; the book version subsequently won the Prix du Livre at the Arles festival. Yet, looked at from another standpoint, the western European photographers had often made more provocative imagery as such; for example, there was a more participatory, eye-of-the-storm feeling to the outsiders' coverage of political rallies and street actions than the eastern photographers managed to convey. Some of this was clearly due to technical limitations: strobes, wide-angle and long lenses, good film, adequate color processing and other tools of the trade taken for granted in the West are still hard or impossible to come by in the East. But there was also a stylistic conservatism at work, as well as a discernible split between fine-art and photojournalistic/documentary practice even more severe than that which afflicts photographers in the West.

Looking at work by such Western exemplars as Eugene Richards, Sebastião Salgado, Mary Ellen Mark and Susan Meiselas, for example, it's evident that they've attended to the full range of contemporary practice, including fine-art and commercial photography, absorbing some of its strategies (an activated frame, startling foreground/background relationships) and applying them to their own ends. This remains unthinkable in the East, where the two forms stand staunchly opposed in all venues, including photo-education contexts. That was brought home to me in a conversation with a Polish curator who went to great lengths to assure me that his institution never-never*never* showed anything that could be thought of as remotely related to social documentary or reportage.

This is unfortunate – not because these various forms should be conflated mindlessly, but because documentary in eastern Europe is still afflicted with social-realist tendencies and the reportage is forthrightly stodgy. In the case of the former, this is not always a drawback ...Yet, on the whole, both forms seem sorely in need of the revitalization that could result from applying radical picture-making strategies to the subject matter of cultures in upheaval. And if those images are to compete in the international media environment, it will not be enough that they were made from within their culture rather than from without; they will also have to look as if they weren't made forty years ago.

In brief, what had been accomplished by week's end? The western European press, and some major representatives of its photography community, had been introduced to a massive amount of imagery from the East – and to sixty of that work's makers. Those sixty, in turn, encountered the West, many of them for the first time. Lectures, workshops, solo and group shows and other forms of exchange will result; some of the photographers who came to Lausanne cut book, magazine, postcard and exhibition deals on the spot. Quite a few of them took the opportunity to buy "small cameras and big lenses," as one of them put it. All of them experienced western-style presentation, and were offered the opportunity to have their work enter a significant western European archive. Friendships and professional contacts were established between the different eastern European nations and outside their collective borders. And the long-term efforts of such visionaries as Czechoslovakia's Anna Farova to preserve their countries' photographic heritage and bring its present-day practitioners into the international dialogue were surely vindicated; in some ways this show was as much a triumph for Farova and her peers – a number of whom, including Farova herself, were present at the grand opening – as it was for the Musée.

What was missed? Not enough attention was paid to bringing the photographers together with each other, and with their colleagues from the West; more parties, more small-group sit-down dinners, and especially more translators were needed. There were insufficient public lectures, discussions and dialogues to contextualize the imagery and create a verbal record of the event in itself. Furthermore, an oral-history opportunity was simply overlooked; someone should have been interviewing each of these photographers for an hour or so, on audio- or videotape. Press attention was not fully mobilized, nor was the publishing industry well-informed; there were book projects and ideas galore here that went unattended. A momentum was initiated but not adequately maintained.

In a flyer handed out at the exhibits, Favrod and Lambelet issued a call for such encounters to take place in Lausanne on an annual basis, with the Musée as host. That's a generous offer, and a great idea. But not enough of the framework is in place as of yet; the project has not been sufficiently thought through. Still, one hell of a start has been made.

Letter from

Letter from New York, No. 21

One of the recognitions encountered along the way by anyone who works extensively in the autobiographical mode is that no matter how fascinating one's own life may be to oneself, not everything about it is inherently significant to others. From this, as a corollary, there follows the realization that, unless one is living a life whose events are extraordinary in and of themselves, the resonance of one's tale depends on the quality of the telling.

Nan Goldin, who's been photographing her own life for a number of years, has come up to that marker in the road, whether or not she realizes it. Touted as the Larry Clark of the '80s, she was widely hailed as a chronicler of and participant in life on the edge in the New York punk scene – not just the heterosexual component thereof but gays, lesbians, transvestites and transsexuals as well, all purportedly interpreted from a post-modern, feminist perspective. Like Clark, she brought a small camera into the intimate lives of an circle of disaffected, angry, violence-prone young people, many of them drug users. Unlike Clark, she worked in color – and never learned to edit. In book form, her *Ballad of Sexual Dependency*, an account of several years in this milieu, was choppy, erratic, and overlong; in audiovisual format – an endless, technically haphazard slide-sound presentation which played everywhere from the city's punk clubs to the Whitney Museum – it was embarrassing in its adolescent self-indulgence and inept craft.

Obviously I disagree with such of my colleagues as Andy Grundberg of the *Times*, one of her champions, who favorably compared *Ballad* to Robert Frank's *The Americans*. But I suspect that, even for an aficionado, Goldin's rudimentary sense of narrative and bad-girl-lays-it-all-bare approach to

storytelling can sustain attention for only so long. Certainly the flabby show she mounted at Pace-MacGill last October emphasized her failings while displaying few strengths and no development either of craft or of vision.

The show consisted of four parts, mostly work from the past two years. There was a grouping of a dozen self-portraits – standard graduate-student fare (made while she was undergoing drug and alcohol rehab two years ago, according to the gallery's blurb). On the adjacent wall hung a similar grouping of images of her lover, Siobhan: portraits, nudes, a photograph of them making love, and another – concluding the sequence – of them about to kiss. The last is quite affecting, but the others are uneven at best; and it's intriguing that a photographer whose admirers claim her as a feminist would make such stereotypically *Playboy*ish studies as these nudes.

The same room contains a selection of larger prints, mostly portraits, of which the two strongest are the blurred, nervous "Sharon at Coney Island" and the luridly-hued "John Heys as Diana Vreeland." Two other images in this group are also powerful: "Matt and Lewis in the tub, kissing," and "Shellbourne in the tub" (though both, once again, could fit right into a skin magazine).

In a separate room, a memorial to Cookie Mueller – an actress, writer, and close friend of Goldin's, who died of AIDS a year ago – was installed. This 15-print sequence spanned 13 years, terminating in a study of Mueller in her casket in November of 1989. Clearly it was meant to be both celebratory and elegiac. But it achieved neither condition, for the images, with only two exceptions, are basically anybody's snapshots, just a little bit artsified; they tell us little about Mueller, less about Goldin, and nothing about the friendship between them. (The exceptions are the melancholic "Cookie and Sharon on the bed, Provincetown," and the ominous "Cookie being x-rayed, New York City," in both of which some thought clearly went into the structuring of the pictures.)

Once you've sought out the spotlight you have to have something to say; there's more to telling stories than just living them out, and half a dozen solid pictures out of fifty is not much of an achievement for a small-camera worker over a two-year stretch.

*

94 *Letter from*

The good news about Barbara Kruger's installation at the Mary Boone Gallery is that nothing in it is for sale, thus at least eliminating the high level of hypocrisy inherent in this artist's usual practice of appearing to decry capitalist consumerism in cryptic, accusatory polemics while selling them for exorbitant prices.

Instead, she's reverted to a variant on her original method of presentation, which involved the pasting up in public places of image-text works in poster form. Here she's plastered the walls, floor and ceiling of the gallery's two rooms (and even the burglar-proof metal gate the gallery rolls down over its facade at night) with her usual mix of petulant prose in bland typography and appropriated mass-media imagery in enlarged monochrome half-tone.

The texts deal with such issues as busyness, revulsion at bodily functions, grief, male sexuality, and the dangers of looking up to anybody or anything. (The last-named counsels are inscribed on the ceiling, which is what passes for irony nowadays.) The images whereon they're overlaid, or with which they're intertwined, include a crucified nude woman wearing a gas mask, a screaming woman, the profile of a man's head with a lock on his brain, a baby nursing on a bottle, and a newborn's head emerging from a vagina.

All of the texts are in Kruger's trademark querulous tone; "Forget heroes/Forget morality/Forget innocence/Forget shame/It's our pleasure to disgust you," reads the crucifixion scene. She's now taken to phrasing some of them as unanswerable inquiries that aspire to the status of a Zen master's provocations – "Who will write the history of tears?" But they devolve, relentlessly, to the merely bathetic ("Who knows that empathy can change the world?") and the downright dumb ("You pledge allegiance to your dick and to the pussy for which it stands?" – presumably her version of a men's-room graffito).

At first glance, this elaborate installation may seem impressive – eye-catching in its dramatic black, white and bright red, and definitely labor-intensive. As one engages with its ideas and structures, however, it gradually reveals itself to be hollow at the core. The hard-edged, commercial-art/agit-prop graphic style on which she depends has lost whatever impact it derived initially from its introduction into the high-art context; in terms of

visual interest, its limitations are severe, and Kruger has pushed it as far as it will go. By now it has devolved into mere fashion.

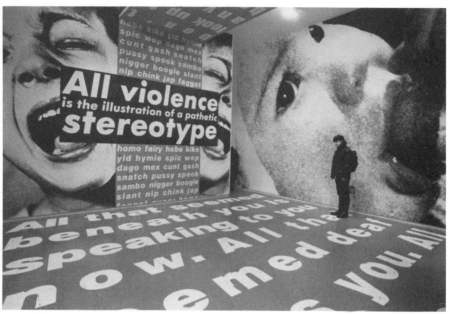

Barbara Kruger at Mary Boone Gallery
© Philip Greenberg 1991

Moreover, her hectoring voice is wearing thin. Add to this the fact that her analysis of social ills becomes ever vaguer instead of more precise, and what you end up with are harangues that resonate with righteous indignation and give all the signals of political correctness but never actually make their point. Complicated rather than truly complex, the result in this case is a neo-rococo environment, involving a great deal of planning and work the actual return on which is minimal – not unlike, say, the set of Pee Wee Herman's Playhouse. It also looks really '80s, and – though I hate to be the bearer of such bad tidings – someone has to tell Kruger that the '80s are over.

Letter from

Letter from New York, No. 24

Postmodernism's hostility to and fear of the faculty of sight is a matter of public record. "The gaze," a purportedly ancient, secret technique of domination hitherto practiced only by men, has been widely identified and demonized as a modern version of the "evil eye." The literature abounds with snide references to "scopophilia," a pejorative neologism that translates as "the love of looking"; in this construct, the very act of seeing stands frequently accused of inherent, pathological voyeurism, with photography as its most pernicious instrument.

So far as I'm aware, no one professing these convictions has had the courage to follow the pertinent Biblical injunction, "If thine eye offend thee, cast it out." But small wonder that the art around which this theory circles offers so little that rewards visual attention; in a climate of such hysterical revulsion at optical experience, who would want to be caught giving or receiving pleasure via the retina?

Sophie Calle's approach to this dilemma of political correctness is to practice a pre-emptive self-criticism, in which she forthrightly confesses herself to be (or adopts the persona of) an unregenerate voyeur. Taking unto herself a presumably male prerogative, the 37-year-old French photographer and writer manifests an aggressive relation to this condition, actively seeking out and/or setting up situations in which she can watch people, either with or without their permission.

Her explanation is that in 1979, returning to Paris after an absence of seven years, she began tagging along after strangers as a way of reacquainting herself with the city. One thing led to another, and soon she was

sending clothing to a man she'd never met, tailing another to and around Venice for two weeks, persuading two dozen men and women to take turns sleeping in her bed for 8-hour shifts while she observed them, hiring herself out as a chambermaid so she could browse through people's belongings – even asking her own mother to engage a private detective to follow Calle about town for a day surreptitiously.

The results of these often elaborate endeavours are image-text pieces that resolve as installations, as bookworks, or as both. Currently a 12-year retrospective of Calle's output is on view at two SoHo galleries (a recent party downtown also celebrated the publication of her latest *livre d'artiste*). They offer an opportunity to take an extended look at what's all the rage among French intellectuals like philosopher Jean Baudrillard, who collaborated on an earlier book project with Calle.

If you can imagine someone trying to integrate conceptual art, "new wave" cinema, and some of the fictional techniques of Marguerite Duras and Alain Robbe-Grillet, you'd have an approximation of Calle's approach. "Provoking arbitrary situations which take on the form of rituals" is how she describes her process. Engaging with the work involves a lot of perusing and/or reading; in two cases – "Anatoli" (1984) at Pat Hearn, and "The Sleepers" (1979) at Luhring Augustine – the installation thoughtfully includes a chair and table so the viewer can take a load off. The former, whose text takes the form of a letter to a lover, is an account of a trip on the Trans-Siberian Railway from Moscow to Vladivostok, sharing the compartment with an eccentric chess-playing divorced man whose given name is the piece's title. In addition to the text, which is stenciled on the wall, the piece comprises piles of several hundred 8 x 10 glossy prints of snapshots of Anatoli during the trip – eating, sleeping, drinking, at the chessboard. Conversely, "The Sleepers" puts 176 pictures, annotated by hand, on the wall in a grid, and includes a book with Calle's elaborate accounts of the time each subject spent in her bed.

Though they're amusing conceits, imagistically these pieces are banal. This is also true of "The Hotel," in which Calle inventories in words and photos what she found in the rooms she cleaned up for two weeks. More effective in visual terms are a peculiar set of enlargements of gravestones

from a California cemetery which indicate not names but family relations: "Twins," "Grandma and Grandpa," "First Wife-Mother-Father-Brother-Sister." The most morally ambiguous of these works is "The Man of the Address Book," from 1983, premised on her supposed discovery of a lost address book in the rue des Martyrs in Paris. Before mailing it back to its owner, she photocopied its contents – and then contacted all the people listed, soliciting from them their accounts of the man in question. (For reasons that escape me, the name of the painter Gericault is given as Jericho in one of these.) This piece, which ran in the Paris daily *Libération* for a month in the late summer of 1983, offers some 30 summaries of her interviews, each accompanied by a thoughtfully-made photo – of the interviewee, or of some significant locale or artifact mentioned in the discussion. The piece culminates with an irate letter from the critic and filmmaker Pierre Baudry, who identifies himself as the subject of all this disclosure and objects vehemently.

That one is mounted at Luhring Augustine, where there's also a 1986 piece, "The Blind," which combines portraits of 23 people who were born blind, their often fascinating answers to Calle's inquiry as to "what their image of beauty was," and her photos of the subjects they named in their responses. At once touching and provocative, it's the one work that most authentically addresses the act of seeing – which is ironic, since its subject is the aesthetic belief systems of the sightless.

Individually, these are all well-made, intelligent pieces. Witty, mischievous, vaguely naughty, Calle comes across somewhat like a French Marcia Resnick. (Does anyone else recall that shooting star of the late '70s?) But cuteness and charm have their limitations; taken in large doses, like this, Calle's efforts wear thin. Lacking the feel of obsession, the pieces become mere bagatelles; their insouciance trivializes the psychological issue she claims as her central concern. There's no intensity of seeing to make palpable the involvement she claims; instead of showing, she tells. But that's the style nowadays – more's the pity, as Calle could be one of those people who actually has something to say.

*

"The moment an emotion or fact is transformed into a photograph it is no longer a fact but an opinion," said Richard Avedon. That certainly applies to the latest installment of Richard Misrach's "Desert Cantos," now at Pyramid Gallery. A stylistic departure from Misrach's ongoing description in color of the past half-century's human impact on the American southwest, "Canto XI: The Playboys" is a brilliant set piece. Its premise is simple: "Two *Playboy* magazines used for target practice by persons unknown were found at the northwest corner of the nuclear test site in Nevada. Although the women on the covers were the intended targets, all aspects of American culture, as reflected inside the magazines, were riddled with violence."

And that is what these photographs depict; filling the frame in these 40 x 50 Ektachrome enlargements are two-page spreads and details of pages from these periodicals, altered by bullets. As the projectiles rip through the pages, they reorder the physical contents of the magazines, generating readymade collages and assemblages. In one – a detail showing a woman's arms, shoulders, and face – you can actually see the bullet, embedded perhaps half an inch deeper in the pages, at the back of what would have been her throat. Elsewhere, Andy Warhol's left eye is blown out; a grinning Ray Charles has his cheek ripped away; assorted depictions of men and women are "riddled with violence"; and the installation's two texts – an interview with the musician/actor Sting, and the quotation "'Twas the night before Christmas and all through the house not a creature was stirring," from a liquor ad – are also shot through with murderous intent. There's even a Marlboro ad, a nighttime cowboy scene in which the mythology of the Old West comes home to roost with a vengeance, achieving in one image what Richard Prince has been attempting for a decade.

The exaggerated scale employed by Misrach makes everything larger than life; it also lets one see every detail of the real damage inflicted on these surrogate, symbolic images. On one level, Misrach's photographs are mere recordative descriptions of found objects – statements of blunt physical facts over which the photographer seems to have chosen to exercise little interpretative control. But, with the application of photography's distancing, observational effect, what would have simply been resonant artifacts be-

Demons (Detail) © Richard Misrach 1990
Courtesy Robert Mann Gallery, New York

come frightening metaphors for our conflation of sex and violence. By transforming these facts into photographs – and by contextualizing them within his ongoing inquiry into the devastation of a large region of this country by the heedless vandalism of both individuals and the military-industrial complex – Misrach has made them his opinions of North American culture. The evidence supports them.

Letter from New York, No. 26

When the earliest photographic processes were competing with each other in the late 1830s, one of the clear advantages that William Henry Fox Talbot's negative-positive process had over the daguerreotype was that it offered the option of making photographic prints on paper, and thus of producing multiple copies of any given image. The halftone process of ink reproduction, introduced in the 1880s, extended this cloning virtually ad infinitum. All of that made possible the application to photographs of other picture-making techniques, collage among them.

These approaches were applied in short order to many of the primary forms of photograph: portraits, postcard imagery, genre scenes, and the like. Yet, though there are numerous examples of photocollage from the 19th century, we tend to think of it as a 20th-century form – for it was shortly after 1900 that, through the efforts of Raoul Hausmann, Hannah Höch and others, this technique entered the toolkit of avant-garde art practice.

Presently, one of the most innovative and resonant bodies of collage incorporating photography ever produced is on view at the Studio Museum in Harlem. "Memory and Metaphor: The Art of Romare Bearden, 1940–1987," which is accompanied by a substantial catalogue, brings together some 140 works by the late black American artist; and, because photography was central to his collage methodology from the middle 1960s until his death in 1988 at the age of 75, roughly two-thirds of this retrospective consists of such imagery. Thus it provides an opportunity to observe a major artist applying the full force of his thought and vision to this process over a twenty-five-year period.

Collage, a vernacular form of picture-making that requires only scissors, paper, and glue for its production, is a deceptively simple process, as anyone who's experimented with it can attest. Bearden integrated it into a practice as idiosyncratic as any in our time, incorporating Mondrian-derived geometrics, African art, watercolor, Cubism, jazz and diverse other elements into a syncretic style that enabled him to generate a mythology at once individual and collective, autobiographical and trans-historical. Most collage involving photographic imagery is disintegrative, due to the fragmentation inherent in the form's patchwork of different perspectives and moments in time. Yet Bearden's manages to be simultaneously unifying, the result of his decision to apply it to a particular subject matter for a specific purpose.

Shortly after turning fifty, some time in the early 1960s – not coincidentally, during the early years of the civil-rights movement, and after passing through successive (and successful) phases of social realism, modernism, and abstract expressionism – Bearden seems to have asked himself how to construct an account of the black experience in North America that was both factual and larger than life, microcosmic and epic. His answer was to begin with the most ephemeral traces of individual lives: photos of black people, often anonymous, as reproduced in newspapers and magazines. From these he took scraps, quilting together an eye from one image, a nose from another, a mouth from a third and a chin from a fourth, not unlike Mary Shelley's Dr. Frankenstein. And, like that visionary's creation, Bearden's paste-pot grotesques suddenly crackled with living energy, as if all the separate souls of which they partook were trying to occupy the new body at once, fighting for control of the tongue.

Then he placed these patchwork entities in rural and urban settings, usually composed of both painted and photographic elements, making them protagonists in archetypal scenes – working, sleeping, eating, loving, living, dying – drawn from his experience of black culture in North Carolina, Baltimore, Pittsburgh and New York. His hybrid progeny brought the paintings to life; the process subsumed the particular into the general, transformed the cumulative into the mythic. Yet, photography working as it does, the particular survived; each of those myriad photographic components bears mute witness to some specific person who once passed before a lens.

Hundreds of these images flowed from Bearden's studio from 1964 on, many of them in series such as "The Prevalence of Ritual," "Of the Blues," "Projections," and "Mecklenburg County." Some of these works, like "Evening: 9:10, 417 Lenox Avenue," are as small as 6 x 9 inches; others, such as the street scene "The Block," a six-panel *chef-d'œuvre*, or "Guitar Executive," are much larger, capable of riveting the eye from the museum's balcony across the room. All in all, it adds up to one of the most lucid, germinal applications to picture-making of the jazz aesthetic yet attempted – a rich, ever-replenishing mix of invention, bricolage, and quotation, in which self-expression and collective memory echo and dance with each other like friends who've played together for a lifetime.

Exhibits of Bearden's work on this scale are a rarity; don't miss this opportunity. As a grace note, a visitor might also get to hear Mr. Satan, the One-Man Blues Band, who plays "real good for free" in front of the NYNEX building a few doors west when the weather's agreeable. Like Bearden, he's both accessible and radically experimental, deserving of full, prolonged and undivided attention.

*

A less eccentric and more issue-oriented approach to photocollage is to be found in Chilean artist Catalina Parra's "American Blues," an installation at Intar Gallery. This project is composed of three sections, the middle one being a set of four appropriated mass-media images, considerably enlarged, each accompanied by a brief poem from the pen of the artist's father, the poet Nicanor Parra. (For example, an image of a young black child raising his hand defiantly is correlated with the punning couplet "Hombre nuevo/ hambre nueva," which translates as "New man/new hunger.")

Flanking this are two sequences in which multiple copies of full-page advertisements from the *New York Times* and the *Wall Street Journal* serve as the ground and framing device for shifting arrangements of media-derived fragments: tigers, US troops, a Marlboro man, the Stars and Stripes aflame, T. E. Lawrence, and much more. It all wears its politics on its sleeve, but my agreement with a number of its assumptions makes it all the more

Letter from

painful to report that the installation as a whole comes off not only as polemical but as tendentious and simplistic. Surely what Coco Fusco's catalogue essay calls "the connection between big business, banking and the military industrial complex" requires more than mere "underscoring" thirty years after Dwight Eisenhower, of all people, warned us against it. And the credibility of the exhibit's critique of multinational capitalism is severely undercut by the Philip Morris sponsorship of the show prominently noted on its accompanying brochure.

Parra has in the past made more complex statements, and made looking at them a more powerful experience; one hopes she will do so again.

*

More and more photographers come to us through the filtration system of the academy. This is true even of photojournalists and documentarians, certainly including that cluster of self-proclaimed "reinventors of documentary" who sprang out of the University of California, San Diego in the mid-1970s and whose imagery has generally proven to be of interest only to other academics.

Nonetheless, it remains possible to become a major documentary photographer without seeking or receiving the art-academic imprimatur, and to produce socially effective work of substance without subscribing to the politically-correct theories currently trendy in the olive groves. If evidence of this is required, one need look no further than Sebastião Salgado, a major survey of whose work, "An Uncertain Grace," is presently on view at the International Center of Photography's uptown branch.

Salgado is a 44-year-old politically exiled Brazilian who – trained as an economist and without any background in photography – took up the camera while working for the International Coffee Organization in Africa in 1973. There could hardly be two more opposite, even contradictory disciplines; economics depersonalizes and generalizes, while photographs specify and particularize. Yet just as the insights afforded by economic theory can contextualize images of individual crisis, so those images can ground and give resonance to abstractions.

It's hard to imagine anyone pursuing both disciplines simultaneously, and indeed, as Salgado recalls, "In a few months I dropped economics and I had a darkroom. Photography became an invasion in my life I couldn't control." Nonetheless, he has found a way of bringing it all back home, generating the images necessary to remind those who tend to think in numbers that real lives are at stake, that flesh and blood stands behind every statistic on famine, pestilence, poverty and death.

Salgado came to international prominence in 1981 with his photographs of John Hinckley's attempted assassination of President Ronald Reagan (he was observing Reagan's "first 100 days" for the *New York Times*), but that spot coverage is entirely untypical of his work. Salgado is primarily concerned not with the movers and shakers, the rich and the famous, nor with unexpected, short-lived crises, but rather with the ongoing oppression and suffering of the poor and powerless, whose lives he addresses in self-assigned, long-term, carefully thought-out projects. These resolve into closely-edited photo-essays such as the astonishing account of workers in the Serra Perada gold mines in Brazil that appeared in the *Times Magazine* a year or so ago, and books like *Other Americas* and the volume that precipitated the present exhibition and shares its title (published by Aperture).

If there's an obvious precursor to Salgado, it would be the late epic poet-cum-photojournalist W. Eugene Smith. Surely it's no accident that he's been a recipient of the W. Eugene Smith Grant in Humanistic Photography. Like Smith, Salgado works in the extended form of the photo essay, and disdains no type of presentational vehicle, using the wall or the page, the original print or the reproduction, as the opportunity manifests itself. Also like Smith, he brings to the situations he addresses a profound faith in the significance of the quotidian experience of the working class and the disenfranchised. Combining what Fred Ritchin (who, along with Sandra Phillips of the San Francisco Museum of Modern Art, co-curated this exhibition) calls a "stately lyricism" with an alertness to the drama embedded in the everydayness of hardscrabble subsistence, marginal survival and imminent death, what he gives us are impersonal statistics come – sometimes marvelously, sometimes terrifyingly, sometimes heartbreakingly – to vibrant life.

An underlying awe at the sheer vitality of people everywhere as they face the job of living and dying infuses this imagery. Not since Smith has anyone photographed manual labor with such deep respect and attentive admiration; but, whatever their occupation of the moment, Salgado approaches all his subjects with the eye of a sculptor, paying particular attention to the way he sets them in the space of the image, using the tactile potential of the photographic silver print to evoke their physicality.

Unlike Smith, however, Salgado does not single out and heroicize individuals as protagonists, following them at length over periods of time. If his vision is, like Smith's, Homeric, it is the Homer of the *Iliad* rather than of the *Odyssey* he emulates, the bard who eschewed the private and introspective for the public and extroverted. The frieze-like gold-mine images from Brazil exemplify this; the overall impression they convey is of a hive or anthill – undeniably composed of individuals, but ones whose individuality flares forth only briefly before the collective circumstance subsumes it once again.

Rather than seeking to persuade us that he, or we, can project ourselves into the psyches of his subjects, he proposes instead that a clear-eyed, empathetic description of their external appearances and visible circumstances can suffice; he does not ask us to imagine ourselves in their shoes, but merely to stand in their space and look unflinchingly at it, and them. Striking this difficult balance with remarkable consistency, he thereby embeds the people he photographs in the complexity of their situations, denying neither their autonomy nor the larger forces against which they struggle and to which they often succumb. For example, by the simple device of looking up rather than down at a nude, gaunt boy – little more than skin and bones – leaning on a walking stick, astride a sand dune, he avoids unnecessarily amplifying the pathos of this child's desperate physical condition, and instead renders as quietly majestic his ferocious determination to live.

At a conference in Philadelphia in the spring of 1990, Ritchin complained at length that museums were not sponsoring enough photojournalistic and documentary projects. One wonders what Salgado would have made of this bizarre lament, which is roughly analogous to holding mortuaries responsible for providing seminars on holistic health practices. As it happens, Salgado's images are structured so richly and printed so finely (not by him

personally, but under his close supervision) that they reward prolonged attention and "hold the wall" acceptably in the context of gallery or museum exhibitions such as this, where they frequently appear. But, fundamentally, they're meant to serve purposes only marginally compatible with those of repositories and showcases for fine art, made instead to be seen in ink versions on the printed page – hardly an enterprise for which museum patronage is either likely or appropriate, at least before the work has been

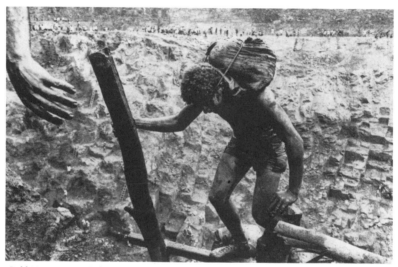

Gold Mine, Serra Pelada © Sebastião Salgado 1986
Courtesy of the Artist

generated and lived its life in the world. For that reason, the photographer works with the picture agency Magnum, and seeks his sponsorship from mass-circulation publications and such organizations as Médecins sans Frontières (Doctors without Borders), a French relief group to whom he volunteered his services in the mid-'80s, during the famine in Ethiopia, Chad, Mali and the Sudan.

The more than 100 black & white images in this show, which occupies the entirety of the uptown facility, sample at length Salgado's three major

projects to date: his intimate, loving scrutiny of the rich diversity of peasant culture throughout Latin America (1977–84); the grim, painful report on mass starvation and migration during the droughts in the Sahel region of Africa (1984–85), 15 months in the making; and what he calls "the archaeology of industrialism," an ongoing exploration of the disappearance of large-scale manual labor beneath the onslaught of high technology. (Not yet resolved, the last-named promises to be the most challenging he's undertaken, if only because the photographer will have to resolve his obvious outrage at the economic exploitation of physical laborers throughout the Third World with his reverence for the skills they've developed and the crafts they practice.)

Individually powerful, these images collectively are very much of a piece, and clearly interrelated. All three of the essays are given ample breathing space here, and this exhibit's only serious flaw is its failure to offer the audience any glimpse of the ways in which these images – most of which have already been widely published – utilize the page as a forum for visual persuasion.

<p style="text-align:center">*</p>

Doubtless there are others who find it remarkable that during a nationwide two-year slugfest over censorship in photography the work of Joel-Peter Witkin did not come up for prolonged debate. I can only attribute this to the fact that whether one is delighted, astonished, appalled or revolted by his imagery, it radiates the absolute authority of the authentically obsessed. And, whatever our persuasion, most of us are still loath to interfere in the doings of holy fools; who knows but that they might be on to something revelatory?

Witkin, whose most recent work is currently on view at Pace-MacGill, functions as a director in the theatre of the taboo, in apparent agreement with W. B. Yeats that the only subjects fit for the contemplation of the adult mind are sex and death. He treads a most delicate balance between the sacral and the profane, addressing the biological differentness of people born physically abnormal, the psychological differentness of people of non-

standard sexual persuasions, and the transformation of the flesh wrought by mortality.

Of all his concerns, it is the latter that seems most profoundly disturbing to the majority of viewers, myself included. It is not just that Witkin makes post-mortem pictures, for photographers have been doing so in various circumstances since 1840. It's that in order to produce his extraordinary works he handles the dead, manipulating them, even playing with them, as if to take literally the metaphor of our flesh as "mortal clay."

Not that far in the past, contact with the dead was a common experience for almost everyone: people bathed, anointed, clothed, prepared for burial and sat up with the bodies of their newly-deceased family members and close friends. In many parts of the world, this is still an everyday occurrence; but in western culture the Victorian era ushered in a reticence that led to an ever-increasing insulation from the quotidian reality of death.

So when Witkin plunks the autopsied cadaver of an infant, along with a severed adult hand and foot and a severed leg and arm, in the midst of a scattering of grapes, pomegranates, crustaceans and octopi, he is not only taking to its logical conclusion the Dutch tradition of the *vanitas* still life with its *memento mori* symbology, but is also violating what has become a deeply entrenched prohibition. It's not just that he envisioned this image, titled "Feast of Fools," as a studio painter might, but that – this being a photograph – the objects it depicts existed and were arranged in that particular configuration by the photographer himself. The sensuous tactility of his rendering of the results thus also evokes his own proximity to and touching of this lifeless flesh, provoking our imagining ourselves doing the same.

This is eerie and unnerving, though one can take some comfort from the fact that Witkin has not been struck by lightning as a blasphemer, and that his subjects don't seem to mind – perhaps because he never seems to be mocking them. To have used as many bodies as he has by now in so many eccentric ways (a woman's face placed on the body of a dog; the vertically bisected halves of a face kissing each other) without once trivializing those who once occupied them is a remarkable accomplishment. His humor, which is considerable and generally genial, is directed instead at our anxieties and his own; his implicit assumption is that whatever the dead leave behind

Letter from

Teatro di Morte © Joel-Peter Witkin 1989
Courtesy Pace/MacGill Gallery, New York and Fraenkel Gallery, San Francisco

when the spirit passes on is ours to do with as we wish, a belief which no doubt will offend some while reassuring others.

In addition to these concerns, Witkin continues his project of recapitulating the entire history of art and photography in capsule form and filtering it through his own inimitable sensibility. Toward that end, this show includes a parody of Courbet's "Studio of the Painter," with a reference to E. J. Marey's motion studies in the lower right-hand corner; a delightful

"Daphne and Apollo" featuring a female midget and a billygoat (the latter probably stuffed); "Vanity," a study of a bull's head with chest skin and hoofs still attached, the beast appearing to stare the viewer in the eye; and "Man and a Dog," a frontal portrait, in the classical style, of a stunningly beautiful nude hermaphrodite and his/her pet.

With what seems to be a not inconsiderable irony in this environment of photographic responses to high-art masterworks, Witkin accompanies "Feast of Fools" with an oil-stick drawing made not as a study for it but "after" it, which reveals him to be no slouch as a draughtsman. That image pays homage also to Frederick Sommer, whose photograph of a severed foot caused great controversy in the 1950s. It is offered here in three versions: the print and drawing just mentioned, and another version of the print, which, along with its frame, has been subtly colored with encaustic. This process, which Witkin has employed before, is one of several evidences in this show that he's intent on keeping his vocabulary expansive.

Another is the return of his earlier blunt, plain style in the portrait "Head of a Dead Man," which shows just that: the profile of a severed head in a white basin (an encaustic-altered version of this image is also included). And a third is the untypically skewed perspective of "Nègre's Fetishist," a deliberately furtive scrutiny of a nude woman with built-in high heels. Though there are only 12 works on view – eight images plus four variants thereof – this is a rich, satisfying, and resolved presentation of the current inquiries of one of the medium's most distinctive contemporary practitioners.

Letter from: New York, No. 27

Communication of any kind requiring as it does the sharing of a symbol system, we might agree that the communicator must choose between three available strategies: accepting some existing symbol system and using it without modification; customizing an existing symbol system by inflecting, nuancing and redefining extant symbols in idiosyncratic ways; or devising and introducing an entirely new symbol system.

By far the largest part of our communicative activity takes place via the first approach, which is why the counterman at the deli does not pause for a moment to think "I wonder what he meant by that?" when you order your egg salad on rye with pickle on the side. Precisely because the established symbol system's structures and connotations are thus predetermined, though, many thoughtful communicators – including artists – choose the middle way, which permits the personalizing to some degree of one's utterances without sacrificing the efficiency that widespread custom facilitates.

Yet this is not enough for those who feel the dominant symbol system as oppressive, malignant, entrapping; like the Cubists in painting, like Joyce and Burroughs in writing, they seek to break down the existing order and replace it with another. Inventing and installing one's own system is a monumental, labor-intensive task, however, requiring the re-education of all involved; moreover, it's a high-stakes game, for unless the new system is rewarding enough to seduce us away from the old its inventor is likely to be left speaking only to him- or herself, out in the cold.

That would seem to be the case with John Baldessari, whose eponymous retrospective now occupies the top floor of the Whitney Museum of

American Art. One cannot help but suspect that its juxtaposition to the show on the lower two floors – the engaging survey "American Life in American Art, 1900–1990" – is deliberate, the Whitney's insistence on giving the tourists of summer something over which to scratch their heads and exchange looks of befuddlement. For, if ever there were a ballgame whose players you couldn't tell without a scorecard – and whose outcome the average person wouldn't be likely to care about in any case – it is Baldessari's.

Man and Woman with Bridge © John Baldessari 1984
Courtesy of the Artist

In the progression established by this survey's 80-some inclusions, Baldessari began as a mid-'60s painter with a tendency toward the cute, self-consciously scratching around in the ruins left by the Duchamp blitzkrieg, painting self-referential texts in black on khaki backgrounds, dabbling in photography by negating rules and assumptions that had long since been discarded by the medium's own avant-garde.

Then, in the summer of 1970, he took a job teaching at the Walt Disney-sponsored California Institute of the Arts in Valencia, and – in a formal, publicly-announced ritual – cremated all the artwork he'd made between 1953 and 1966 in his possession at that time. (A loss that no one, to my knowledge, bemoans.) Thereafter, primarily employing the lens media – still photography, video, film – he became what was called a conceptual artist, making films, videos, artist's books, and suites and sequences of images that documented the enacting of eccentric pre-planned ideas. For example, he photographed himself attempting to throw four balls in the air in such a

Letter from

way that they'd form the corners of a square or to blow cigar smoke in the shape of certain clouds, and waving goodbye to departing boats in the harbor.

When he put the torch to his past, he declared, "I felt art was too elite an activity, not made for the average person. So I began to draw on my everyday life for ideas, and I said, I'll do the lowest common denominator: the kinds of texts and photo imagery people see in newspapers." True to that tenet, these mildly ironic works – though simplistically crafted and intellectually slight – are generally accessible, amusing and engaging, if not resonant. Yet even then Baldessari was not immune to the arcane. For instance, the 1974 triptych "Embed Series: Cigar Dreams (Seeing Is Believing)," in which cigar smoke spells out the words of that significant and much-disputed homily, depends for its impact on the viewer's awareness of the controversial research of Wilson Bryan Key, who claimed that the makers of such humble products as Ritz crackers had the word SEX "embedded" subliminally into advertising photos of their wares by retouchers with airbrushes.

By the 1980s, Baldessari was moving away from this conceptualist approach to a manner that I would have to call intentionalist – because its meaning emerges only after the artist elucidates it. Using mostly found images – film and publicity stills, newspaper "grip and grin" shots, magazine imagery, and such – he began generating elaborate constructions. The images he employs are mostly black & white to begin with, but sometimes they're in color; or he may hand-tint them, or add painted elements – in particular, white or variously colored circles that cover people's faces, giving them somewhat the appearance of moronic "Have a Nice Day!" cartoons who've had their features removed.

All these colors have specific meanings that the works themselves don't make available; to discover them one must go to the critical apparatus, the most convenient one at the moment being this traveling exhibit's handsome, well-produced accompanying catalogue by Coosje van Bruggen, co-published by Los Angeles's Museum of Contemporary Art (where the show originated) and Rizzoli International. Occasionally one can tell the players without this souvenir program; in the charged, resonant "Man and Woman with Bridge," the line of sight between a couple is occupied by an interpo-

lated image showing a fox tentatively stepping out (from the woman's side of the collage) onto a narrow horizontal pole, pithily summarizing the sexual dynamic. But what is one to make of a 1980 triptych titled "Baudelaire Meets Poe," in which, ascending from left to right, the artist offers a snake stretched out, a snake wrapped around a diamond ring on a woman's finger, and a frog seen from underneath?

"The frog stands for an explosion made at the moment of impact of the two minds meeting," the artist is quoted as saying. Since frogs don't normally carry that connotation, the only respectful response to this assertion is, "Well, if you say so, John" – a curious bowing to authority extracted by an artist who purports to be anti-authoritarian. Frankly, I would doubt that most of Baldessari's champions and acolytes, confronted with his work of the past decade but their memories of his explanations thereof erased, could agree even on what ballpark he was playing in, much less what particular works meant. Which is why discussions of it, like van Bruggen's, center around what Baldessari says the work means. Such intentionalism, once considered a fallacy in criticism, has now become a style in art.

To be sure, Baldessari's 1980s work all has that fashionable, generic, postmodern look: visual banality, the quotidian recycled, an approach to craft that impeaches sight and touch. No doubt this means that, by definition, it announces the end of western civilization, critiques the current stage of terminal capitalism, and tellingly references Lacan, Baudrillard, Kristeva, and that lot. And for those who like that sort of thing, there's plenty of it here. Myself, I'm struck by the fact that a major New York institution would fill a floor with work by a man who declares, "I think artists are more sensitive to boredom, and artists are better at finding a way to kill their time, and so they make art." Whose boredom Baldessari is sensitive to I couldn't say, but it certainly isn't mine. Perhaps the Whitney, as a museum of American art, might want to keep in mind the wisdom of Hank Thoreau – might indeed even inscribe it over its portals: "Who thinks that they can kill time without injuring eternity?"

Letter from

Letter from: New York, No. 29

As *I've noted here* on various occasions, a surprising number of painters who take up the camera reveal in their results a profound incapacity to grasp the fundamentals of photographic seeing. Consequently, few of them produce durable, significant or even interesting bodies of work. Unexpectedly (given my lack of appetite for his paintings), David Salle provides evidence in a recent show and new book that he could say something substantial with photographs. At the same time, regrettably, like Melville's Bartleby, he makes it clear that he "prefers not to."

The work in question is a set of some 60 monochromatic nudes, photographed with a Nikon Instamatic in the studio, that were shown at the Robert Miller Gallery and published simultaneously by the gallery in a hardbound edition (*David Salle: Photographs 1980 to 1990*) with an introduction by Henry Geldzahler. Both are handsome productions; the prints (not generated by Salle himself) are rich and thoughtful, with a slightly sallow cast that contributed to their overall uneasiness, and the reproductions capture their nuances well.

Scrutinized under a harsh, concentrated light, often a single spotlight, Salle's subjects are seen theatrically, detachedly, yet also almost obsessively. *Almost* is the operative word there; a sense of the fetishistic, the voyeuristic and the surreptitious lurks in the atmosphere of these images, but rarely materializes. Perhaps that's because these images were made, essentially, as sketches towards his canvasses – as play and experiment, rather than as finished works. From the internal indications, Salle simply brought to the sessions different props, whimsically chosen – a Pierrot costume one day, a

© David Salle
Courtesy Robert Miller Gallery, New York

violin or an oversize cutout of a light bulb another – and noodled around awhile with each. None are turned into resonant symbols (though a few images come close), and the painter's explorations of them are rendered even more fragmentary by the gallery's decision to hang and publish them in a random order, so that no two consecutive images share a common motif.

Nevertheless, for my money they're more tactile, more unnerving, and more emotionally charged than anything he's rendered in pigment. Yet I suspect the artist never took them seriously, and their public appearance

Letter from

likely has more to do with the market (making possible the sale of a comparatively low-cost multiple) than with the resolution of a body of work. That doesn't take place; in fact, it doesn't seem to have been essayed – more's the pity, since when his painting ends up in the dustbin of art history Salle and his admirers could have had his photography to fall back on.

*

As one who for decades has urged photographers to turn their attention and their cameras toward their own socio-economic classes and milieux, and as one who has written at length (and sympathetically) about the autobiographical mode in photography, I can hardly complain – at least in principle – about an exhibition such as "Pleasures and Terrors of Domestic Comfort," which has just opened at the Museum of Modern Art. For, certainly, it represents a case of those particular chickens coming home to roost.

Though curator Peter Galassi's title is more poetic, the show could just as easily be called "The Art-Educated, (Mostly) White Middle Class of the United States Photographs Itself At Home in the Eighties." It is from the bourgeoisie that most of today's young Master of Fine Arts degree-holders in photography and the other media come, after all; and, like dutiful young writing students, they are doing the photographic equivalent of "writing about what you know." The sad part of it, based on the evidence of this show, is how little they seem to know: only the brand name of everything, but the meaning of nothing.

Patently, this is a generalization, and I'm sure an unfair one. With its 150 prints, the exhibition and its accompanying monograph – which, with a long introductory essay by Galassi, does not merely catalogue the show but instead presents a somewhat different set of pictures – is not an appropriate basis on which to judge any of the almost 80 photographers, none of them represented by more than half a dozen images and most by only one. A number of the bodies of work touched on here (I'm thinking, just for example, of Jock Sturges, Sally Mann, Larry Fink, Gary Brotmeyer and Eileen Cowin) are extensive, durable and resonant, though you might not guess that from what's on view. But this exhibit is not intended to show-

case and explore the personal visions of its contributors; it's a theme show, based on a curatorial thesis under which the imagery has been subsumed. In that sense, it bears an odd resemblance to its most obvious precursor at MoMA, Edward Steichen's magnum opus, "The Family of Man" – except that, in this case, rather than a search through the files of the international photo community for images reflective of some global commonality, a more reductivist, literal-minded approach to the premise has been taken, giving us a look at what a specific generation of photographers from a specific culture and class background have been attending to in their own backyards, living rooms, kitchens and dens. And therefore it's as a curatorial endeavor that it must be assessed.

In his carefully-wrought essay, whose thrust (if I may call it that) is that these photographs indicate something unspecifiable in middle-class private life has gotten vaguely but perhaps seriously out of kilter, Galassi consistently practices what I'd call pre-emptive self-criticism. For example, he points out, quite correctly, that most of these photographers don't know – or even know of – each other, and that this work has not emerged from any formal, organized movement on their part. True enough. But he neglects to mention that virtually all of them received their grounding in photography through the North American academic fine-art institutional network. Surely he must be aware of the guiding rule of the French Academy: in historian Albert Boime's words, "Control instruction and you will control style." Does the simple fact of their indoctrination as a privileged educational cohort not go a long way toward explaining some obviously shared concerns – as well as the unnerving homogeneity of their imagery, which is so interchangeable that it's generally difficult to tell whose work is whose? The curator asks us not to read this work principally as sociology, and – though it has data and even information to convey on that score – that is surely not the only or even the primary level on which it's intended by its makers. But there is a sociology of the college-trained photo-making caste that demands consideration in this context.

Pictorially speaking, the overall tone of this imagery is that of the family album; though this is not true of those photographers working directorially, like Frank Majore, Jo Ann Callis, Bruce Charlesworth, Cindy Sherman,

Letter from

The Two Sisters © Albert Chong 1987
Courtesy Catherine Edelman Gallery, Chicago

Laurie Simmons and Philip-Lorca diCorcia, it even dominates the work of such montagists as Colleen Kenyon and Lorie Novak. Yet Galassi cautions his readers against thinking of these images as simple snapshots, and he's quite right; they are, instead, complicated snapshots. In them the pictorial strategies of Garry Winogrand, Lee Friedlander and William Eggleston – whom Galassi declares to be the progenitors of those on view, no doubt in homage to his own mentor, John Szarkowski, an indefatigable sponsor of all three – are applied to the traditionally domestic subject matter of the snapshot. What results, as a rule, are self-consciously aestheticized glimpses of the incidental aspiring to the status of the eventful.

Emotionally, the show's tenor is distraction. Only rarely do any of the adults portrayed seem to be entirely there. Consistently, they're depicted as not in concentrated interaction with their environments, with the other people and animals in their lives, or with the photographer. Often the only one seeming to pay attention to anything is the photographer – and to what he or she is attending is not necessarily always clear. Taken collectively, the show could pass as a set of film stills from the sets of a generic movie whose script had been distilled from all those Gordon Lishified *New Yorker* short stories and the novels of Ann Beattie, Mary Robison, and similar others, in which the characters can't ever get the emotional cotton-wool of their own self-absorption out of their ears long enough to make contact with each other.

Sufficient direct reference to this branch of contemporary literature is made by Galassi in his introduction that it's clearly very much to his taste – which, in turn, may serve to explain his selection of images to illustrate this sense of unarticulated dysfunction. But the suite he's assembled does not manifest even the provocatively lurid obsession of a David Lynch, much less the nuanced, delicate surgery of a Tolstoi. Count Leo, you may recall, opened *Anna Karenina* by observing, "All happy families resemble each other; each unhappy family is unhappy in its own way." If that's truly the case, why is it impossible to tell these supposedly unhappy families apart?

As in Buddy Hackett's old routine about assuming the perennial heart-burn induced by his mother's cooking was the flame of his life-force, what we have here is a dyspepsia mistaken for angst and anomie. I'm reminded of Joshua Gilder's description of Ann Beattie's purpose (in a *New Criterion* review) as "the avoidance at all costs of meaning; not *meaning* in any ex-alted sense of the word, simply identifiable thoughts. This is not necessarily an easy task; allow enough words to assemble freely in one place and one has to be constantly on guard that they don't organize themselves into an idea. Even in the short story form this can be a problem." The same holds true for photography too, I might add. By those lights, Galassi and – to whatever extent he's represented them accurately by his selection – many of the photographers in this show have been relentless in their vigilance.

Letter from

Letter from: New York, No. 30

. . . at *Metro Pictures*, there was an installation by Laurie Simmons that partook of both the sculptural and the photographic. It comprised seven photographs, three of them in color and all but one of them 53 x 89 inches in size (the largest is slightly more than 8 x 20 feet), plus three ventriloquist's dummies. The images portray more of the hybrid objects Simmons has been concocting for the past several years, in which the legs and lower bodies of dolls (female, with one exception so far) are joined to such artifacts as a clock, a miniature toilet, or a toy house. Photographing these creatures in a featureless space, then enlarging the resulting images enormously, Simmons has obliterated their actual scale, making them lifesize. Though patently mute, they speak poignantly and sometimes fiercely of the roles imposed on women by society.

This newest batch included a woman-book, a woman-fountain, a woman-accordion and – my favorites – a woman-globe (she being bent over by the sheer weight of the world as her upper half) and a woman-pistol, titled "Walking Gun," as direct an emblem of female rage as I've seen. Dominating the main room in which the photos were installed was the largest, titled "Magnum Opus (The Bye-Bye)," in which a number of these miscegenated totems meet, as if at some sorority party in hell.

In the lower gallery, perched on small chairs mounted on the wall, sat the three dummies – Charlie McCarthy clones, dressed variously in casual clothes, bathrobe, and tux. Collectively titled "Clothes Make the Man," these refer back to a previous piece by Simmons, a wallful of publicity portraits of female ventriloquists; but in this context they also functioned as

Sitting Microscope © Laurie Simmons 1991
Courtesy of the Artist

the male counterparts to the female icons upstairs. Taken ensemble, these bitter, angry visions of the male and female condition propose a bleak and hopeless future. If the subtitle of the largest of the photographs suggests that this particular project of Simmons's is concluded, it may be because it's left her with no place to go.

<div align="center">*</div>

As a matter of general principle having nothing whatsoever to do with aesthetic quality or inherent significance and everything to do with art-market traditions and collectors' ignorance, paintings as a generic form of artwork can be sold at higher prices than photographs. And, given their $80,000 price tags, this explains why the Sonnabend Gallery presently is taking great pains to identify as "paintings" (further defined as "screened oil inks on canvas") what are for all intents and purposes a set of oversize enlargements of photographs: the hard-core erotic images depicting Jeff Koons

Letter from

carnally entwined with his Italian film-star wife, Cicciolina, that are the focal points of his current exhibit, "Made in Heaven."

There's no question that it's these 11 color photographs – each rendered 5 x 7-1/2 feet, thus making the figures usually lifesize or larger – that have generated the media blitz surrounding this show. Though they're no less sexually explicit, the other erotic works in the show (typically tacky sculptures in marble, Murano glass, cast plastic and polychromed wood, the largest of which Koons reportedly hopes to sell to the Vatican Museum) carry nothing like the charge inherent in the photographs. This has more to do with something inherent in the nature of photography – its particularizing capacity – and, of course, with the subject matter and the presentational context, than it does with the photographs themselves, which are quite competently made but stylistically conventional within their genre.

No doubt this flamboyant display of the artist and his muse in rut will evoke reams of discourse, including the predictable *fin de siècle/fin du monde* analyses. It'll be fascinating to see how the art world comes to terms with such blatant, unabashed heterosexuality – and, in plague time, with such willfully unsafe sex (oral, anal, genital, exchange of fluids, no protection). None of this is deathless art, nor is intended to be; part of its point is that it's nothing more than ephemera writ large. Clearly, this project – an elaborate honeymoon album produced for their adoring fans – is intended as parody of the insatiable US appetite for public confessionalism and gossip about the sex lives of celebrities; looked at in that light, Koons and Cicciolina have certainly one-upped the Geraldo Rivera-Bette Midler debacle. Its thrown-gauntlet challenge to the current wave of comstockery – and to the institutional and artistic self-censorship induced thereby – is unswervingly confrontational.

As a provocation, it's unquestionably successful, not least because it exposes the bedrock of hypocrisy beneath the current hysteria over things sexual. That first Saturday afternoon, one could eavesdrop on TV and print reporters interviewing gallery-goers for stories that would be aired or printed at great length without any illustration of the works in question, which the mass media would inevitably censor; and it was highly amusing to watch the opening-day overflow crowds – most of whom wouldn't be

Jeff Koons: *Dirty – Jeff on Top* 1991
Photo Credit: Jim Strong

caught dead with a copy of *Hustler* on their coffee tables – demonstrably having a great time staring at enlarged close-ups of Koons's phallus and Cicciolina's vagina and rectum.

For this curious, calculated and highly-orchestrated event focusses attention on a problematic truth: one of the severe polarities that currently rends our culture is between those who enjoy sex immensely and those who don't. Of those who do, a great many – women as well as men, if one is to judge by attendance at this show, not to mention the autobiographical accounts contained in Nancy Friday's new survey, *Women on Top* (Simon & Schuster) – like to look at pictures of people fucking. A considerable number, in fact, like to record themselves in the act – and, though it's more professionally rendered, what Koons has put on view here isn't much different in kind from what millions of Americans have produced over the past few decades with Polaroids and portable video cameras. Not a few of them have even made such material available to others – home videos and amateur photos of the couples next door going at it are widely distributed.

Letter from

But none have had at their disposal a gallery of the stature of this one, whose sponsorship of this event surely justifies the profound faith expressed recently in *Connoisseur* magazine by Ashley Bickerton. In a discussion of his choice of Ileana Sonnabend over Mary Boone as his representative, Bickerton said, "I asked myself one question: five years down the line, if I want to shit in the corner of the gallery, put up a plaque, and call it a show, who out of Mary and Ileana would let me do it? The answer was obvious, and that's why I'm here." Bring on your millenium, I say; by the time it arrives, for better or worse, I'll be ready.

Letter from: New York, No. 31

A definite schizophrenia in the critical response to AIDS-related art seems to be manifesting itself at this stage in the plague's history. On the one hand, there's the constant (and correct, and appropriate) insistence by various spokespersons that AIDS is not only a disease afflicting gays, lesbians, and IV-drug users, but that everyone's at risk and we're all in this together. Simultaneously, however, there appears to be a contingent that wants to *own* the AIDS issue lock, stock, and barrel. The premise of the latter ideologues is that no one who's not gay, lesbian, HIV+ or AIDS-diagnosed has the moral authority to speak in any way to this subject.

I realize that, as an uninfected heterosexual, my perception of this situation may well be limited or skewed. But, as a critic, how else am I to explain the fact that a shapeless, irrelevant, hyperbolic extravaganza like Marvin Heiferman and Lisa Cremin's "The Indomitable Spirit" is widely judged to be so politically correct in its intentions that discussion of its curatorial incoherence, intellectual laziness and lack of conceptual pertinence to this crisis is nowhere to be found? Or the fact that, at the same time, a serious, long-term inquiry on the level of Nicholas and Bebe Nixon's *People With AIDS* (along with other AIDS-related projects by dedicated photographers) has been subjected to persistent attack and disparagement?

The book version of *People With AIDS* has just been published by David R. Godine, but extracts from it have been exhibited and published for the past several years; some were included in his 1988 monograph, *Pictures of People*. Begun in 1987, the project tracks in words and sequences of photographs the lives of 15 individuals after their diagnoses as AIDS-infected.

The images – all made consensually and collaboratively – are mostly trans-actional portraits, their subjects aware of and participatory in the making of the picture. The accompanying texts are, with few exceptions, in the words of these ailing people and those who loved, cared for, and stood by them, transcribed from conversations and selected from letters.

There is in photography a tradition (it goes back to the very beginning, with daguerreotype) of what's called the "post-mortem" photograph: stud-ies of the body after death, often handled as a form of portraiture. And, in a sense, all photography of the living can be considered "pre-mortem," in that it describes people who are going to die; that's why the emotional affect of even the most inept snapshot deepens when its subject has passed away. But, while it's not implicit in all the individual images, Nixon's sequences are inevitably and to some extent self-consciously about the impending deaths of those they portray, who are rapidly wasting away and literally dying before his lens and the viewer's eyes. (Indeed, by the time this book went to press last spring, all but one of the people scrutinized in it were dead.)

There are precedents for most aspects of this work. Its combination of portraiture with the subjects' own testimony is a by-now classic strategy of social documentary in photography. Formally, Nixon's monochromatic imagery is thoughtful and conservative; stylistically, his most notable achievement is the supple, almost casual intimacy he manages to achieve with the large-format camera he utilizes. (One consequence of this is that the prints he makes from the resulting 8 x 10 inch negatives are comparatively grainless – unlike, say, the high-contrast enlargements of Brian Weil – so the subject matter, rather than the process, dominates the attention.) Others – Richard Avedon with his last portraits of his father, Mark and Dan Jury in their book *Gramp* – have addressed physical decline and death. Even the friendship, mutual respect and rapport the Nixons attained with those who spoke with and posed for them, while evident and admirable, is not ground-breaking. Nor, I'm sure, would this book's self-effacing authors claim otherwise.

Were this project about people suffering from and (with one exception) terminally ill with some less politicized disease – leukemia, say – it would be easy to see it for what it is: a solid, intelligent, empathetic study of individu-

als in crisis, squarely in the mainstream of the social-documentary tradition. Not surprisingly, the PWAS who chose to commit themselves to working with the Nixons proved to be articulate, forthright and courageous. (They include a gay political scientist who advised a Presidential Commission, a hemophiliac banker, and a black prostitute, all from the New England area; they came to the project through Boston's AIDS Action Committee.) In some cases, their afflictions left them abandoned by those on whom they depended; in others, their plight evoked the heroic in those they loved. They narrate their own stories candidly and movingly; particularly telling is the recurrent belief that the virus was in some strange ways a gift enabling those it infected to shed the inessentials of their lives, including self-destructive behavior patterns, and embrace whatever mattered to them most. In the words of Tom Moran, "Who cares how you come to health, as long as you come to it?"

The Moran sequence, comprising eleven images, is one of the most difficult and painful in the book; the final portrait, made in his hospital bed just days before he died, is almost unbearably ghastly. Yet he, and most of the others represented, repeatedly express their pleasure at the opportunity this project provided – whether they conceived it as entertainment, self-exploration, a chance at a sliver of immortality, or a platform from which to educate others. As Joey Brandon's father says, after his death, "he told his mother and I...that no matter what he ever said, Nick was to take the pictures...Somebody needs to look at the ugliness of this, that these are people, that they're loved by somebody, that somebody cares."

AIDS is perhaps the first fatal disease ever to be not only documented exhaustively from a medical standpoint but covered journalistically and interpreted artistically from almost the first moment of its recognition as a new ailment. I'd guess that there's been more recorded response to AIDS produced over the past decade – in photography, art, theater, film, video, fiction, poetry and music – than was stimulated by the entire course of the Black Plague. Healthily, this discourse includes everything from the blameful rage of David Wojnarowicz to the unexpectedly supportive voluntarism of a California branch of the Rotarians (whose members sponsored a remarkable prime-time TV special this past summer).

Letter from

If this is indeed a scourge that involves, threatens and impoverishes us all, as I believe it is, then the only sane position is to encourage serious responses to it from every sector of the community. There is no single "right" way to interpret this disease, nor to commemorate those extinguished by it. History will sort out those who contributed meaningfully to the public dialogue from those who wasted their time and ours. In the meantime, I don't think we can afford to turn on anyone willing, like the Nixons, to look squarely and empathetically at those whom AIDS is ravaging and killing. This ceremonial, elegiac album is a substantial and valuable document of the last days of some of them.

Letter from: New York, No. 32

As gossip columnist Liz Smith reminded us not too long ago, the French Symbolist poet Gerard de Nerval – who'd eventually come to a bad end, hanging himself with his girlfriend's underwear – used to walk a lobster on a leash in the Tuileries. When asked why he kept this crustacean as a pet, he'd invariably reply, "Because it doesn't bark, and it knows the secrets of the deep."

William Wegman's weimaraners, on the other hand, do bark; and though they may not know the secrets of the deep, Wegman is convinced that they understand the function of the still and video cameras before which he places them. While that's surely debatable – no evidence supports the proposition that dogs recognize or respond in any way to two-dimensional imagery – there's no question that they've internalized the dictum about not biting the hand that feeds them. Indeed, they've virtually reversed that advice, supporting the man who turns them into laughingstocks; the most famous of them, the late Man Ray, achieved international celebrity for himself and, arguably, for Wegman through his uncomplaining, deadpan appearance in countless photographs and videotapes.

Dogs enjoy learning tricks and thrive on attention, so I'm not suggesting that Wegman is in any sense cruel to them – though one of the videotapes on view in his current traveling retrospective at the Whitney Museum of American Art, in which Man Ray has to break a milk bottle and nose through shards of glass in order to get at a bit of food, left me a bit uneasy. On the whole, he's just another guy playing with his dog, teaching him a variety of what talk-show host David Letterman dubbed "stupid pet tricks" and the

similar shenanigans to which we're treated on "America's Funniest Home Videos." The main difference between Wegman's efforts in this regard and those of thousands, perhaps millions of other pet owners is not only that his canine collaborations are recorded for posterity, but that the results are presented as art activity.

Wegman works in other media – painting, drawing, and printmaking – but it's safe to say that he's best known for the color photographs of his dogs made with the Polaroid 20 x 24 camera. A selection of his earlier black & white photo works is included in the Whitney show, and some additional examples are to be found in the concurrent Pace/MacGill exhibit emphasizing that phase of his output. For the most part, these are excruciatingly self-conscious and cute, positively reeking of art school; they belabor small ideas in a sterile mating of conceptualism and minimalism. In general, their photographic quality – that is, their potency and sophistication as imagery – is deliberately low. But there's evidence even here that Wegman at least understood that photographs could be compelling; pieces like "Cotto" and "Pinking" from the 1970s are intelligently structured images as well as clever visual puns.

In an insufferably coy, mutually self-serving dialogue with Whitney Director David Ross that opens the big show's accompanying catalogue, Wegman announces that with the making of "Cotto" – in which his hand, with some little circles drawn on it, is seen laying out slices of salami on a plate – he discovered that, "Eureka ... I could construct a picture and that way directly produce a work – not a secondary record of it." This would hardly have been news to photographers, who'd already been doing just that for over a century, but it's the sort of reinvention of the wheel in which academically trained artists who avoided sitting through even a basic course in photo history continue to take great pride. A few years thereafter he introduced his dog into his scenarios; and when, in the late 1970s, he began working with the 20 x 24 camera – which produces a one-of-a-kind Polacolor print that size – he found an ideal vehicle for his ideas: it required no darkroom activity, provided a sumptuous, sensual print, and was best suited for staged events in the studio.

The images that have resulted from this ongoing exploration are, taken in small doses, engaging, wry, and witty. The artist wrapped Man Ray in

aluminum foil and leopardskin-print fabric; dusted him with flour and rouged his face; disguised him as a bat, an elephant, and a frog. His newer models have been garbed in an assortment of dresses and wigs, often posing in the company of women, sometimes so arranged that the resulting images are grotesque combinations of a dog's head with a woman's body. Any one of these can make you laugh out loud. And a few – such as the crotch-grabbing *belle dame* of "Gesture" and the *plein-air* odalisque of "Sleeping Rock," both on view at a second concurrent exhibit, this one of recent Polaroids, at Holly Solomon – are disturbing and even haunting.

But mostly they are, as Robert Frank has said, "dumb dog photographs." Repetitive structurally, humoristically little more than one-liners, they wear thin quickly. And the extensive survey of Wegman's photography that's constituted by the Whitney overview and the two accompanying gallery showings makes the work's superficiality all too apparent. I don't begrudge Wegman his good fortune in making a career in art out of being good with dogs, but surely this is overkill.

<center>*</center>

Whoever it was who said that once you've learned to fake sincerity you've got it made might have been speaking about Deborah Turbeville's current installation at Staley-Wise, "El viaje de la virgen Maria Candelaria." Not that Turbeville is consciously pretending to be sincere; after several decades in the fashion industry, I suspect that comes as naturally as breathing.

What she's done is to make a lot of what are basically tourist snapshots of small-town street scenes, weathered Christian icons and such in Mexico and Guatemala. (They're not unlike the images my mother – herself a competent amateur – made in those same locales in those same countries when she and my father honeymooned there in 1945. Unsurprisingly, for anyone who knows a little history, not much has changed for those who live there.) She's had them printed up in a variety of ways – as Fresson color prints and as monochrome prints; the latter, made by Dawn Close, are variously manipulated and toned, and are often on torn pieces of photographic paper. Some of these she's collaged together with newsprint, waxed paper, old

rotogravure sections and cut-up shopping bags, holding them together with pins and tape; and some of these she's had framed (by Larry de Martino) in funky, rusty, crumbling tin and carved-wood frames. Others she's just pinned directly to the gallery walls, which she's had wrapped with kraft paper.

The whole has at first glance a pleasantly low-key, rustic ambiance, no doubt akin to that of Turbeville's house "in the highlands of Mexico," which served as her home base for this project. But it quickly turns appalling, as one becomes all too aware that what the anonymous working-class and poor people who populate these several hundred images are for Turbeville is merely a source of "atmosphere." That's her word for it, not mine. In a statement inscribed directly on the kraft paper by the door, she writes, "There is for me a whole other atmosphere here that I feel has altered my vision . . . Another mystery, other faces, other textures . . . different light. It is not about my beautiful anorexic women clinging to collapsing walls in outrageous couture clothes but yet another 'endangered species' the noble women of the Mayan and Aztec races, their heads held high in defiance of the constant threat to the survival of their culture as we see it today." (Ellipses hers. I invent nothing; I merely report.)

I can add little to that, except to say that I find deeply offensive the pretensions to social concern of a fashion photographer who can't be bothered to tender those she's photographed the simple courtesy of learning how to spell the name of their native land. (Did I hear someone say, "Thank God she doesn't have to?") Along with her credits to her printer, her framer, and her cryptic master of tricks, she might at least have thanked the nameless oppressed people of Mexico and what she calls "Gautamala" who appear in her images – none of whom, I'd wager, were asked to sign model releases permitting the use of their portraits in this blatantly self-promotional campaign, and none of whom are likely to benefit economically from a merchandising project whose cumulative list price, according to the gallery, falls just shy of $306,000.

*

As if to compensate for the media heat of its Yuletide Jeff Koons extrava-
ganza, Sonnabend has mounted its second photography show in recent
months – this one a remarkable installation of 34 superb monochromatic
seascapes by the Tokyo-born Hiroshi Sugimoto, who's lived and worked in
New York since 1974. It's a project diametrically opposite to its late-fall
predecessor in this space; if the Koons was a brass band fanfare, this is a
flute solo.

Standing high on cliffs overlooking the ocean in various geographic lo-
cations (the North Atlantic, the Pacific, the Mediterranean, the Aegean, the
Arctic, the Sea of Japan and the Black Sea are only some of his sites), Sug-
imoto has positioned his large-format camera carefully, framing each vista
so that the horizon line divides his images exactly in half: the sky above, the
sea below. There are no distinguishing geological or man-made features to
these scapes – not a single reef or jetty – nor any trace of the land on which
the photographer stood. The minuteness of the whitecaps and ripples, and
the occasional dusting of faint white speckles that one eventually realizes
are flocks of birds seen from far above, suggest that the height from which
we observe the scene through Sugimoto's lens must be considerable: a
God's-eye view, as it were.

This repetitive image structure – a precisely bisected rectangle, the bottom
half darker than the top – is the organizing principle of the exhibit. Yet, even
in the closely-related images assembled as two triptychs, the scene is never
really the same; indeed, the variations are fascinating, and potentially end-
less (the project began in 1986 and is, in fact, still ongoing). Sugimoto has
photographed at all times of day and night and in all kinds of light, from
bright and crisp to dull and fog-bound. In some ways, this suite is akin to
Alfred Stieglitz's germinal "Equivalents" series – a set of images of clouds
whose content was their form and tonal structure. It's also an almost exact
inversion of Hokusai's classic strategy for his famous series of views of Mt.
Fuji, in which that artist studied the same mountain from dozens of different
vantage points. Sugimoto, instead, maintains one vantage point and lets his
subject do the changing.

Which it does. Sometimes it's the sea that comes vibrantly alive; some-
times it's the sky. Sometimes the two elements radiate equal but quite

Letter from

different energies; and sometimes mist so diffuses the light that the horizon line disappears and the middle of the image pulses with its absence. The seven night pictures, which are contained in a room of their own, are the subtlest; they look like little more than uniformly black rectangles until your eye adjusts to their nuanced tones, a process that can take several minutes.

But then, this is work made for people who like to look at photographs long, hard, and closely. The 20 x 24 inch silver-gelatin prints, made from negatives big enough that their renderings are virtually grainless, are flawless individually. But this installation is a whole greater than the sum of its parts; it is, in fact, a tone poem, whose pace, variety, delicacy and balance are deeply gratifying. To any proposal that landscape as a subject is exhausted it gives the lie, just as it impeaches the notion that the significant questions concerning photographic seeing have all been answered. It's a challenge and refreshment for the mind, the soul, and the eye. That this gallery has supported Sugimoto's work for over a decade speaks well for its understanding of the medium, and suggests that the medium's future within the high-profile commercial venues for art is not necessarily as bleak as some – myself included – are often wont to believe.

Letter from: Houston, No. 34

Houston FotoFest '92, the biennial Texas-scale "International Month of Photography" mounted for the fourth time in its home city from March 7–April 5 of this year, was better than ever, in deep trouble financially, making big plans for the future – and possibly coming to New York. All of which was pretty much business as usual for this ambitious enterprise, aside from the contemplated voyage east. That venture would bring a self-contained chunk of FotoFest's 30 official exhibitions – most probably its Latin American component – to the Big Apple sometime in the not-too-distant future.

The project of traveling some of the exhibits FotoFest organizes and sponsors is still very much in the planning stage; among the other cities being considered as stops on such a tour are Minneapolis, San Francisco, and Chicago, with Caracas, Mexico City and Bogota also possible. But this decision to consider what is, in effect, the franchising of the operation to various other parts of the continent raises an inevitable question: Has FotoFest outgrown Texas?

Some people argue that it never belonged there in the first place; to a considerable extent, it's there simply because those who conceived it during the mid-'80s – photographers Fred Baldwin and Wendy Watriss and gallery owner Petra Benteler – are Houstonians all. Houston is not an international art or photography center otherwise, nor a major drawing card for tourism. And the city's post-oil boom economic woes mean that FotoFest must look outside its own home grounds – to Eastman Kodak and other such sources – for much of the financial support it requires.

The creation of FotoFest was inspired by such photography-specific international events as the long-running annual Rencontres Internationales

de la Photographie in Arles, in the south of France, and the biennial Mois de la Photo in Paris. These projects are not exactly trade shows on the order of ArtExpo here in the States or ARCO – Arte Contemporaneo – in Madrid; they're more a cross between the conference and the festival. Yet because they serve as venues for the presentation of exhibits of imagery from around the world, and bring together photographers, publishers, editors, curators, gallery owners, critics, historians and other specialists from the international photo scene for formal and informal exchange, these events function as marketplaces and showcases for a wide span of photographic imagery and related activity.

FotoFest was the first US attempt to create such a nexus, and though its failings have been many – as Baldwin and Watriss, who now mastermind the project as a team, readily admit – its successes have by all estimates far outweighed them. Enormous quantities of significant photographic imagery of all kinds, both historical and contemporary, have been presented here; much of that wealth of material has come from abroad, a goodly portion of it from regions rarely heard from (eastern Europe, Latin America). In most cases it's never been shown here previously; not infrequently, it's never before left its country of origin. And though it's hard to calculate the exact consequences of the networking that this occasion stimulates, the interaction among those who attend contributes much to the growth of what I've come to call the International Image Community.

However, unlike Arles, a small Mediterranean town dotted with Roman ruins, whose size and layout encourage walking about and informal socializing in a central plaza, Houston is the epitome of urban sprawl in a car culture. In 1986 and '88, FotoFest followed the Arles model by mounting the exhibits it sponsored in existing venues around the city. This was fine for Houston residents and others from the surrounding region, who knew the city, had cars at their disposal, and had a month in which to absorb the offerings; but it proved unworkable for the student groups, out-of-towners and foreigners who form a large portion of FotoFest's audience. So, in 1990, and again in 1992, FotoFest took over a third of the George R. Brown Convention Center, where it houses those exhibits officially under its auspices (some 30 this time around; another 80 "satellite" exhibits mounted

in conjunction with the event were dotted around town, in museums, galleries, libraries, universities, restaurants, and other venues).

The sheer volume of imagery on view this spring was daunting, as ever, and hardly anyone saw it all. This time, however, FotoFest's organizers had solved virtually all the presentational problems (save overdose) that plagued the event in its previous incarnation. The design of the installation at the convention center gave each exhibit its own clearly demarcated space while also providing a sense of flow and pace. And the concentration on two geographic regions – Europe and Latin America, each represented by both archival and current work – created a sense of chronology and continuity.

Even within those structures, the diversity remained remarkable. The European component incorporated a 30-print selection from Charles Marville's documentation of the reconstruction of Paris under the urban planner Baron Georges Eugene Haussmann; three dozen Woodburytypes of John Thompson's studies of 19th-century London street life; "The Illegal Camera," clandestine reportage from the Netherlands during World War II; a survey of recent work by black photographers from the UK, titled "Inside Out," that included some particularly powerful image-text pieces by Claudette Holmes; and a retrospective of the ever-astonishing scientific photography of Lennart Nilsson (author of *A Child is Born*).

Within this European segment there was a particularly potent group of exhibits. Its foundation was "Photography at the Bauhaus: The Formation of a Modern Aesthetic, 1919–33," comprising some 100 vintage prints from the 10,000 original prints housed in the Bauhaus-Archiv in Berlin. Curated by Jeannine Fiedler, who also authored the accompanying monograph, this show – whose sole trans-Atlantic stop was FotoFest – made available a wealth of material rarely seen even in reproduction: works by Herbert Bayer, Laszlo Moholy-Nagy, Lucia Moholy, Florence Henri, Umbo, Walter Peterhans, and many others – including students. . . . From there one could step into "Art, Industry, and the State," which took a close look at the long-forgotten Soviet propaganda magazine *USSR in Construction* in its heyday, the years 1930–36, when artists and photographers like Alexander Rodchenko, Varvara Stepanova and Max Alpert applied Bauhaus and Constructivist ideas to its layouts, its overall design, and even its physical

form – using die-cuts and other experimental techniques (even tucking a folding paper parachutist into an aviation issue) that were radically advanced for their time. This show, curated by Rune Hassner of the Hasselblad Center in Sweden, who's made a long-term study of this subject, presented 14 original issues of the periodical along with Canon Color-copier prints of many more covers and spreads.

A few paces further on, there was a retrospective of Karel Teige's Surrealist collages. Influenced by the Bauhaus and Dadaism as well as surrealism, Teige, a Czech critic, produced much collage imagery between 1935 and his death in 1951. From his work – witty, playful, satiric and, especially in his last few years, extremely erotic – one can trace a lineage to such diverse contemporary practitioners as Allen A. Dutton and Romare Bearden. Little of this imagery has been seen outside of Teige's native land, so these 48 examples (most of them one-of-a-kind originals from the collection of the National Writers Museum in Prague) were a particular delight. And not too far away, either physically or ideationally, though half a century less old, were the autobiographical montages and photo-objects of Poland's Wojciech Prazmowski and the various experiments of the 14 photographers – notable among them Galina Moskaleva, Andrey Chegin and Valery Potapov – included in "Photo Manifesto: Contemporary Photography in the USSR."

The historical section of the Latin American segment included Estaban Garcia's documentation of the "War of the Triple Alliance" in Uruguay in the 1860s; Marc Ferrez's late-nineteenth-century landscapes of Brazil; formal studio portraits of Catholic functionaries – many of them in allegorical costumes and poses – in Guatemala at the turn of the century; a survey of early twentieth-century Peruvian work by Martin Chambi, Sebastian Rodriguez and others (this included a magical Chambi self-portrait holding a negative self-portrait); imagery of Medellin, Colombia made between 1870 and 1920 by Meliton Rodriguez, Benjamin de la Calle and Jorge Obando, one of whose panoramic prints of a demonstration in Cisneros Plaza discloses the hand of US cultural imperialism, in the form of a Coca-Cola sign on the side of a building, looming over the crowd; and "Crossing of Cultures: Four Women in Argentina, 1930–1970," which brought together the

work of transplanted Germans Grete Stern and AnneMarie Heinrich, both of them Bauhaus-influenced, with the later social-documentary efforts of Alicia D'Amico and Sara Facio, whose *Humanario* – a study of conditions in a madhouse – was censored when first published but forced reforms in the treatment of the insane.

Group shows predominated in the contemporary portion – Brazil, Argentina, Uruguay, Venezuela and Colombia were all represented in this fashion – and their coherence varied considerably, as did the quality of their contents. Of these, the most organized and engrossing was "In the Eye of the Beholder," the first public showing of a selection of 57 black & white prints of anonymous reportage from the El Salvador Archive, a secret collaborative account of political activity in that country over the past decade, accompanied by extensive explanatory and historical text. The Colombian survey incorporated works as diverse as Bernardo Salcedo's delightful, Joseph Cornell-derived assemblages involving found portraits and Becky Mayer's installation combining huge color enlargements of morgue images of victims of political assassination with an unfortunately vague text holding the US somehow accountable for their deaths. Venezuelans represented included Alexander Apostol, who makes dense, complex, toned montages and collages, sometimes altering his negatives and sometimes building the images up in layers of fragmented prints. Indeed, there were discoveries to be made and pleasures to be found in all these shows, but none of the exhibits save the "Secret Archive" seemed to have any particular points to make.

There were also three solo shows by contemporary Latin American photographers: an overlong 84-print retrospective by Flor Garduño of Mexico, work I've long admired but which doesn't sustain an unsystematic sampling on this scale; "Nupcias de Soledad," a group of large, photographically based assemblages by Luis Gonzalez Palma of Guatemala that have the feel of ritualistic objects; and seventeen 30 x 30 inch black & white prints of close-up portraits and allegorical studio nudes from Mario Cravo Neto of Brazil. Though FotoFest provided more explanatory text in general this time out than it has previously, the Latin American section in its entirety, and the contemporary portion thereof in particular, called for much more than it received; there was little to indicate what this work was about in terms

Letter from

of its cultural references. (One happy result of FotoFest's gathering of this work is that Rice University Press has committed itself to producing a major book based on it; perhaps that will serve in part to rectify this problem, even if only retroactively.)

I saw only a sampling of the satellite shows – quite a few of them didn't open during the first week – but there were many first-rate ones. Among my favorites:

... The posthumous retrospective devoted to 62 prints from Tseng Kwong Chi's "The Expeditionary Works," curated by Jean Caslin for the Houston Center for Photography. This deadpan parodic suite of ersatz tourist snapshots by a Chinese-American artist who died in 1990 at the age of forty can be thought of as documentation of an extended piece of performance art or as a purely photographic project, and works equally well under either rubric. Dressed in Mao jacket, sunglasses, and an ID badge, Tseng took advantage of "photo opportunities" large and small, using his 2-1/4 inch-format camera to record himself standing before tourist attractions of all kinds: Niagara Falls, Checkpoint Charlie in Berlin, the Eiffel Tower, Mickey Mouse in Disneyland, a tree somewhere in Puerto Rico, the Grand Canyon. This installation, most of whose black & white prints were 36 inches square, was at once humorful, charming, and disquieting. Individually, the images – which are traditional in structure – are only slightly odd; collectively, they form a deeply comical yet ultimately ambiguous commentary – on the communist world's appetite for capitalist luxuries, on the various options for veiled self-assertion even within totalitarian cultures, on the idiosyncratic nature of our choices as to what we consider memorable.

Finally, worthy of special mention was "TAFOS: Social/Cultural Images of Third-World Peru," at the Innova Design Center. This show was primarily a set of "newspaper boards" produced by participants in rural communications workshops in Peru, who were taught the basics of photography and journalism and set to work on their own concerns and issues. The resulting images, which are first-class examples of documentary photography, address soup kitchens, public demonstrations, work life in the mines, pollution, political assassination, right-wing violence, and much more; assembled into a narrative titled "It is a long way to go," they revealed the daily lives of

those who produced them cogently, and movingly, and from the inside. This exhibit is an outgrowth of Los Talleres de Fotografía Social (TAFOS), which translates as The Social Photography Workshops, a project started in Lima ten years ago by Thomas Müller, a German photographer. It's a prime example of what can happen when people are empowered to represent themselves in words and images....

By opening day on March 6th, some ten thousand schoolchildren were already scheduled to visit; by the end of FotoFest's run this year, some 33,000 people had come to the Convention Center, while overall attendance figures at all FotoFest events and sites were estimated at a quarter of a million. The operation ran at a substantial loss, much of it the combined cost of convention-center rental fees and Meeting Place outlays; but as of late May roughly half of that had been recovered, and Fred Baldwin anticipated being in the black by September. Perhaps the festival's fiscal and logistical problems will sort themselves out. This may be the last time it functions on its recent scale. "One thing we learned is that we don't need 30 exhibits in the Convention Center – so we'll probably reduce that number considerably," predicts Baldwin. "But we'll always work with some thematic ideas. Photography provides you with surprising linkages, and we want to be able to act on those, without straining them."

"We're a museum without walls," he continues. "Flexibility is a quality we prefer over the stability of establishing ownership of a hunk of real estate and becoming a physical institution – though there are decided advantages to doing so. But we're more and more looking at FotoFest as an'educational delivery system of sorts," a concept that promises to involve them in greater cooperation with other institutions, both locally (Rice University and the University of Houston are looking at ways of integrating FotoFest activities into their curricula) and, on a national level, with the International Center for Photography and other such venues. It may also take them in the direction of making a much greater amount of imagery available through digitization and computer-based retrieval systems than FotoFest's experiments to date in that regard have offered.

If the projected tour does materialize, the next version of the event may be postponed until 1995, which would provide a bit of breathing space, and

Letter from

time to solidify financial and organizational structures. In addition to deciding what it wants to be when it grows up, FotoFest's most urgent problem remains that of becoming integral to the cultural life of the city which houses it, the region in which it takes place, and those with a serious interest in art and photography here in the US.

One would hate to see it leave Texas; that would only contribute to the unhealthy myth that art activity matters only when it happens in a few select cities. Yet, as it stands, FotoFest has more direct impact on the photography community abroad than it does on that constituency here in the States. Perhaps the best way to rectify that is indeed the contemplated plan to spread the wealth. Speaking for the audience here in Gotham, I feel it's safe to say that New York wouldn't mind becoming the beneficiary of such a version of Texas largesse. And I'm sure that's true of audiences elsewhere in this country – and across the world, for that matter.

Letter from: New York, No. 36

By now, several generations of photographers in the US have come to maturity assuming that, as has long been true for artists in other media, their private lives – including even the most intimate passages in their sexual, marital and parental relationships – are appropriate subject matter for their work. In recent years, however, this now-widespread belief and the resultant imagery have come face to face with vehement disagreement. Among its opponents are political conservatives who argue that such imagery undermines "traditional family values"; religious fundamentalists who consider it immoral; radical feminists who construe it as sexually exploitative; and government censors intent on equating it with child pornography and sexual abuse. The bodies of work of Sally Mann and Jock Sturges are representative of the many that have come under scrutiny and attack on these various grounds lately; for that reason, and because these two photographers know and support each other's efforts, it seems fitting to consider their projects in tandem.

*

Imagine yourself standing at one end of a long picnic table on the expansive open deck of a house in the Virginia woods. It is a hot, clear day, rich with bright sun and deep shade. Someone has just returned from the garden bearing fresh-picked tomatoes, half a dozen of which sit on the table before you. The table is drenched with light. And suddenly, from out of nowhere, an angel appears on it. She has the appearance of an eight-year-old girl, her naked body lean as a whippet's, but she is so soaked with the sun streaming

down from above that she is almost translucent and surely intangible. With arms raised and toes pointed, she is demonstrating how one dances on the head of a pin. Transfixed by this vision, you cannot look away or focus elsewhere. But from the corner of your left eye, blurrily, you see another young girl, astride a man's lap in the shadow of the house, who mirrors your astonishment, her mouth dropping open in awe at this miraculous apparition.

These are not times in which any save the most fanatical of fundamentalists are prone to speak of angels, yet Sally Mann's best photographs of her three children – and particularly those of her two daughters, Jessie and Virginia – consistently put the viewer in the presence of what I can only call the angelic. By this I mean nothing in any way Disneyfied – nothing at all pixieish, frilly, frivolous or cute. These beings are serious, often gravely so; they are accustomed to being, and expect to be, taken seriously. Yet while fully in and of the world, more so than the ephemeral adults who occasionally serve as counterpoint to them in this microcosm, they seem to be, in Wordsworth's phrase, still "trailing clouds of glory," alighting on the quotidian like young migratory birds reaching the flock's winter home for the first time.

Reviewing Mann's last solo New York show, more than three years ago, I connected her family-photographs project to the work of some predecessors in this terrain, and though I might now add some others to that list of possible analogues and influences – early Arthur Tress, W. Eugene Smith, Nancy Rexroth, her friend Jock Sturges – Emmet Gowin and Melissa Shook still seem to be her most obvious precursors. Indeed, there's one photograph in her current show at Houk Friedman, a 1991 image titled "Yard Eggs," that seems uncannily to continue two scenarios described by Gowin twenty years ago. In one of Gowin's tableaux, two little boys, their heads bent in discussion or argument, stand at the corner of a rural garden fence; two upside-down metal pots are at their feet, and in front of them two chickens engage in their own dialogue, the rhythm of the image emerging from this dance of pairs. In the second, a young girl, her face a study in sweet, shy pride, displays her double-jointedness by sinuously interlacing her arms – which, in combination with her hands, each one holding an egg, appear to be some uncanny externalization of her Fallopian tubes.

Mann's related image gives us a girl-child standing at the corner of what could pass for the same garden fence, though seen from a slightly different angle, holding out to the viewer a hat full of eggs – as if fulfilling the unfinished chore of the distracted boys in the first of Gowin's images and

Candy Cigarette © Sally Man 1989
Courtesy Houk Friedman Gallery

extending the promised, symbolic fecundity of the second. Is it a response to Gowin's work, conscious or not? Is it coincidence that both work in Virginia – or, for that matter, that Mann's first child is named Emmett? I couldn't say, and am not sure it matters. More important is that the resonance of these photographs reaches beyond the individual bodies of work in which they're embedded; their reverberations cannot but be sensed by anyone who's tracked the evolution of photography over the past several decades.

Letter from

What makes Mann's pictures notable is that she places her considerable skills as a picture-maker – including patience, deliberation, a classical sense of form, a musician's ear for the tonalities of silver, and absolute mastery of her tools and materials – at the service of her commitment to looking as clear-sightedly as possible at the young. She demonstrated that capacity in her most recent book, *At Twelve*, a study of girls on the edge of puberty. Yet the current show probes much deeper than did that project, because what she is addressing here is – in the title of the exhibit, and her just-published monograph (Aperture) – *Immediate Family*.

Some of these three dozen images have been shown before – the earliest, "Damaged Child," dates from 1984 – but quite a few are new. It's now evident from their accumulation that this work-in-progress is an ongoing photographic interpretation of the daily life and development of three children, as seen from their mother's perspective. Consequently, the intimate, familial, and biological connection between the photographer and these particular children is palpable in the photographs – is, in fact, an essential aspect of their subject matter and their emotional content.

Yet, along with autobiography, this project incorporates elements of poetry, and fiction, and theater; which is to say that it aspires to and attains the status of literature. Mann invites the viewer inside her family, using a diversity of means to do so. Her 16 x 20 inch prints from view-camera negatives are large enough to render the children close to life-size; the sumptuousness of her remarkable prints makes them and their world tactile; the lens's proximity to them and their fearlessness of and self-disclosure to it bespeak a trust accorded only to parents and special friends. In that context, these children's frequent, self-confident nakedness seems so natural and right that even remarking on it requires apology for the repressed, aberrant world beyond its borders – a world in which "Rodney Plogger at 6:01," which portrays an unclothed, four-year-old girl nestled against a man's legs and belly, is more likely to be mistaken for a representation of child abuse than for evidence of that same child's sense of total security.

The viewer is also welcomed into a physical environment that feels like "the forest primeval" – a dense, safe, enticing darkness in which there's much to be seen for those willing to look slowly. This darkness dominates

most of Mann's images, the main source of whose light is frequently the radiant bodies of her main subjects. Sometimes, however, as in "The Bath," she works at the opposite end of the tonal scale; or, as in "The Perfect Tomato" and "Jessie at 6," handles the merger of both extremes with equal aplomb. In all cases the eye is invited to caress what the hand cannot.

Yielding to this seductive vision privileges one to enter a now-mythical terrain; neither Paradise nor Eden, it's simply a land in which a reasonably healthy, happy nuclear family engages enthusiastically with itself and with nature. That this seems so refreshing, and so noteworthy, suggests that what we've come to accept as a norm may be much less than what we need and want. But this body of work is not a critique of society; it's simply a door opening into one small corner of an alternative universe – less than perfect, to be sure, but better than what's on sale in the media mall today.

It is precisely because the immersion in this family's psyche is so engrossing – and because Mann is as forthright in revealing herself through her images as she is in exposing her children to our scrutiny in them – that it becomes possible for the viewer to observe the nuances of difference between her images of the girls and those of her son. Mann attends to him no less closely, and looks at him just as forthrightly. But she does not quite manage to look into Emmett as she does with the girls – and as they do into her in return. Perhaps that's asking too much; it may be something only a father could do. I'd certainly be interested to see what she might achieve if she consciously and systematically turned part of her attention to finding a way of addressing male children – her own in particular. But, so far as I am concerned, she need change nothing in what she's doing; I hope she'll continue making such pictures as these forever.

*

Eight years after my first encounter with the work of Jock Sturges – examples of which accompanied his application for admission to the graduate program at the San Francisco Art Institute, where I was a visiting lecturer in the fall of 1982 – he and I still hadn't met. Though I'd never forgotten those images, I hadn't seen much more of his work, only a reproduction

Letter from

here or there. Then a storm cloud that he clearly never expected – and whose dimensions even I, who've written about censorship in photography for close to a quarter of a century, would not have predicted – broke over his work.

Though they couldn't have known it at the time, Sturges and his subjects were to be changed forever by their participation in this project. Those alterations are not yet over, and, though perhaps inevitable, are certainly not for the better. All concerned appear to have been operating in a cocoon of innocence that could not have lasted for long unrent by the beaks and claws of our cultural pathologies. Injury has been done to the human subjects of this work and to its maker – and, not least of all, to the work itself. For, even if only in its role as an unintended locus for governmentally-sanctioned sexual abuse, this visual inquiry has been changed as well, its context dramatically redefined. There is no way to restore it to what it was, or was meant to be, before the deluge. But perhaps we, as audience, as the intended recipients of this extraordinary gift, can seize it back from those who've stolen and perverted its meaning. Redeeming it thus, we might heal it, and those who made it, and ourselves.

Last October, at a symposium titled "Photography and Censorship" co-sponsored by the American Society of Picture Professionals and the Camera Club of New York in the Eastman Kodak building on 43rd Street and Sixth Avenue in New York, I finally got to meet Jock Sturges. By then I'd been following his harrowing adventures for a year, through reports in the press and word of mouth. All I knew was that, hounded by the Federal Bureau of Investigation in a bizarre intercontinental witchhunt at an expense to the taxpayers of over a million dollars, Sturges had survived an attempt to destroy his life and his work and was now countersuing that agency.

The highlight of the symposium for me was meeting and listening to Sturges, whose level-headedness and eloquence were remarkable considering the year-long ordeal he'd been put through. Hearing his explanation of his project, seeing (too briefly) an extensive selection of images from it, and learning the details of what turned into a waking nightmare for him was profoundly disorienting; the pictures and their purposes did not seem to belong in the same tale as their persecution. Yet they do, for reasons I'll get

to in a moment; and though the punishment hardly fit the crime, Sturges is, as I told him that evening, clearly guilty of an excruciating naïveté.

Recapitulated briefly, Sturges, who's based in San Francisco, has for years been photographing young people whose families practice nudity. He's done so with his subjects' permission, as well as that of their parents, who often appear in the photographs along with their offspring. Rejecting the use of standard model releases, with their blanket permissions, the photographer chooses instead to request approval from his subjects for each and every exhibition and publication of each and every image – an exemplary scrupulousness. For almost a decade, he worked in this fashion without incident. Then, in 1990, alerted to the "questionable" content of some of his images by a local processing lab, the FBI arrested Joe Semien, Sturges's assistant, invaded the photographer's San Francisco studio without a warrant, and seized all his prints, negatives, records, and equipment; thereafter, without arresting Sturges, or even charging him with anything, they refused to return his property and did everything possible to destroy him personally and professionally by branding him a child pornographer. Only when a grand jury found no basis whatsoever for an indictment did they drop the case and begin returning his property to him – much of it damaged beyond repair.

Of the many injustices in this case, the one least mentioned is the distraction of our attention from the work itself, and the distortion imposed on any attempt to grapple with the complexities of what Sturges has achieved therein. As one might expect from an artist still in his early 30s, it is an uneven and unresolved body of work if looked at as such; the sudden prominence into which it has been thrust is not one it achieved on its own intrinsic merits – as the photographer himself is the first to admit. Put in perspective, it's a work-in-progress that is neither complete nor finally redacted. In that state of abruptly arrested development, it's been rudely pushed center stage, not especially to its benefit. Yet there it is. Leaving the baggage of this work's recent history behind, attending to the images themselves and what they have to tell us, has therefore become an extraordinary challenge. Rising to it is the only way to transform the situation.

Photographs are of course about their makers, and are to be read for what they disclose in that regard no less than for what they reveal of the

world as their makers comprehend, invent and describe it. Considered in that regard, autobiographically, I'd suggest that what's offered in this body of work is the ongoing inquiry of a heterosexual male who's trying to understand how girls become women – and, perhaps, seeking thereby some insight into what a Jungian would call his own feminine aspect. Sturges was, self-confessedly, a bookish manchild, as was I. It's my belief that for those like us the female of the species comes to constitute a profound mystery; some turn their backs on it, but more than a few spend their lifetimes trying to decipher it.

These efforts can be clumsy or delicate, brusque or patient, puerile or mature. They are almost always poignant, because the mystery is, finally, not to be solved; the differences between the genders are such that on some levels we must always remain radically other to the opposite sex, and incomprehensible. Yet, at its best, the serious attempt to address this otherness from either side (for there are women photographers pursuing this issue as well) is vitalizing, charged with dynamic tension and the immanence of growth.

At his best, what Sturges has accomplished in his project, as reflected in the 58 images collected in his new monograph, *The Last Day of Summer* (Aperture), and in the additional and subsequent images I saw on display this past summer at the Charles Cowles Gallery in New York and the Vision Gallery in San Francisco, is the sustaining of a most precarious balance along a very fine line. One can read this suite's energies as the consequence of its engagement with multiple polarities: between public and private, between tact and frankness, between childhood and adolescence, between male and female, between artist and model. There is no question that these portraits are consensual, and transactional. The grainlessness of the prints bespeaks the utilization of a large-format camera, which eliminates the possibility of the rapid and surreptitious glimpse; this deliberation is underscored by the formal, often stately way in which the photographer defines his proscenium. If one needs more evidence of the subjects' awareness and acceptance of the photographer's presence, one can attend to the distances between the two encoded in the images, the subjects' generally direct look through the lens, and their obvious calm and composure during these acts of conscious self-revelation.

It seems to me particularly noteworthy that so many children and adolescents – young people in the throes of developmental phases that often evoke painful shyness and excruciating anxiety concerning the physical self – would choose to see themselves, and let the world see them, through this particular man's eyes. For that's surely part of this transaction, and part of the energy flowing through this suite: these girls (and a few boys, and some of their parents) are standing naked in front of a man. His profound interest in them is evident in the images, and is surely manifest in the ritual of this photographic situation; yet no less patent is the fact that he has no designs on them, no ulterior motive beyond struggling to see and render them in all of their complexities, trembling on the cusp of change.

What eventuates from this exchange are collaborations in the process of making metaphors of metamorphosis. That these mutual endeavors require the establishment of trust should go without saying; that this trust has not been violated is demonstrated by the fact that Sturges's collaborators, and their parents, have given permission time and time again for the pictures to be shown and published, have posed for him year after year – and that some of his earliest subjects, now grown and with offspring of their own, have entered their own children into this cycle of scrutiny.

The result of this long-term, communal effort is one of the most clear-eyed, responsible investigations of puberty and the emergence of sexuality in the medium's history. Had the integrity of his intentions not been palpable, Sturges could never have evoked this degree of openness from his young partners in candor; and had he not been able to construct for his cast of characters a photographic safe haven, a theatrical environment in which their performance of selfhood in transition was treated with the gravity, respect and gratitude it deserves, his intentions would not have earned him permission to continue, and to make public his results.

Yet that is exactly where Sturges could be said to have betrayed and deceived his subjects. Not consciously, not deliberately, and surely not maliciously – there's not an ounce of malice in these pictures, nor greed, nor treachery. No, what Sturges is guilty of is a naïveté so bone-deep that it is both heartbreaking and, in a man his age, inexcusable. For clearly he believed, and persuaded his subjects, that their fragile truths were not only safe

Letter from

with him but in no danger from the world. The latter was never true, pretty though it might have been to think so; indeed, as I said to him that night during the symposium, to the extent that it was meant to resolve as a set of publicly displayed images, this inquiry was imperiled from the start – fated, like its subject, to exist only briefly in its pure state.

I'm not speaking here, in sentimental terms, of the almost inevitable loss of innocence that accompanies maturation. Sturges's blindness was not to the evanescence of his human subjects' moments of passage (to which he is, on the contrary, most precisely attuned) but to the diseased condition of his own culture. His flaw was his failure to foresee the consequences that would ensue from making photographs fit for a psychologically mature, sexually healthy society and introducing them into an emotionally retarded, sexually disturbed one. For the finest of these photographs are reverential, even sacral images; neither they nor those involved in their making had much chance of enduring unbrutalized for long in our profane, polluted, neurotic environment.

Probably these photographs would never had been created had Sturges or his subjects suspected where they would lead. So, just as their unawareness of their social context made the pictures possible, the pain and grief of their disillusionment is the price they've paid for what they attempted to say. The only way to thank Sturges and his friends for their efforts is to struggle toward remaking the world in their image – that is, to work toward creating a culture in which such brave, forthright investigations are seen as normal, and their repression is the aberration.

As this body of work's public history makes all too apparent, the United States at present is not prepared for such images, nor for those who engendered them, and does not yet deserve either. It will take great effort on the part of us all to prepare the way for them, and others of their caliber. Their service to us so far is to alert us to the enormity of the task ahead – and to give us a foretaste of what awaits us when it is done.

Letter from: New York, No. 37

One of the challenges faced – and acknowledged – by contemporary Latin American photographers is that of moving past the photographic imagery of their various cultures, produced by foreigners, that has predominated to date in representing the lands "south of the border." After all, most of the best-known photographic images of Latin America have been made by Europeans or North Americans – Robert Frank, Edward Weston and Paul Strand, for example. So one can empathize with these homegrown photographers' impulses to evolve a set of approaches to the medium through which they might generate imagery reflecting more authentically native and even indigenous cultural understandings.

Yet their efforts are and will continue to be, by necessity, problematic. Not only has that imagery by outsiders embedded itself in photography's history and in our cultural consciousness, but photography itself sprang out of western European culture and is, if not inherently Eurocentric, certainly infused with assumptions that derive from European systems of thought and perception. And compounding this situation are the conflicting desires to avoid what Latin American critics deride as the merely "folkloric" – the reiteration of the ethnographic, the traditional and the "quaint" – while at the same time engaging with the deepest issues of cultural mythology, social history, and ethnicity.

One-person shows by two Latin American photographers – one Brazilian, the other Guatemalan – who are actively grappling with these concerns have opened here at the outset of this fall season. Some three dozen silver-gelatin prints by Mario Cravo Neto, from Bahia, can be found at the Witkin Gallery;

and 27 pieces by Luis Gonzalez Palma of Guatemala have been installed at the Lowinsky Gallery. Both men have shown previously in the US – much of the work now on view was presented at FotoFest in Houston last February, for instance. Yet with these exhibitions they each are making their solo debuts in New York City. Though quite different stylistically and emotionally, these two bodies of work have much in common, and the relationships between them are instructive.

Both photographers work virtually exclusively in the studio, functioning directorially, making formal studies of people that combine aspects of portraiture, still life and the nude. Their human subjects are generally scrutinized from up close, and are adorned with, juxtaposed to or interactive among objects that, within the proscenium established by the lens, become charged with ritual significance. Some of these objects are artifacts: a mask of a crescent moon with a face, a headdress made of feathers, a harlequin suit, a wreath of twigs. Many of them are natural: flowers, leaves, stones, bones, a tortoise shell. Of these, a few, like the two large fish hanging over a man's bare back in one of Cravo Neto's images, were recently alive; others – the dog and goose in several nearby prints of his – still are.

In the theater of these images, the implicit function of these props is not only symbolic but fetishistic; they intimate that the viewer is being made privy to the practices of some pantheistic faith. Yet they remain cryptic and elliptical, so that the viewer – not unlike a tourist witnessing religious rites from a culture not his own – observes the form without penetrating the mystery.

Cravo Neto and Gonzalez Palma appear to share an impulse to generate what might be called substitute realities – iconic images in which the mundane and the mystical entwine to generate new mythologies. What they're essaying can be thought of as a photographic version of the "magical realism" of Marquez and other contemporary fictioneers. Yet if they have that impulse in common, they diverge widely in other ways – not just stylistically, but in their envisioning of the future.

Now in his mid-40s, Cravo Neto gained prominence as a sculptor before turning to photography. That earlier relation to craft makes itself felt in his finely rendered 16 x 16 inch silver prints, in which the carefully considered forms under inspection are precisely positioned in the photographic spaces

Odé © Mario Cravo Neto 1989
Courtesy of the Artist

they occupy. These spaces are deep, often dark, hushed but inviting; the eye
is inclined to enter and linger, to wander among the tones and textures that
are revealed in the prints. It is a highly tactile world, evoking the inclina-
tion to touch, as if proposing that one's senses might lead one to the bridge
between cultures that the mind alone cannot locate. For all its quietude, it is
an optimistic world that bursts with life – much as the head of a baby, seen
from the proximity and vantage point of a nursing mother, thrusts against
the frame in the image titled "Akira."

By contrast, the song sung by Gonzalez Palma is a threnody. Younger than Cravo Neto by a full decade, he comes from a background in architecture, painting and cinematography. Except for one gravure collage, his pieces are all silver prints, often overlapped to make larger constructions: "La Loteria," a grid of portraits, is 57 inches square, "El Harlequin" is 20 x 60, and "Restless Place I" – a melancholic line of empty chairs – is 24 x 79-1/2. The monochrome images are sometimes selectively sepia-toned, and sometimes overpainted with an transparent, brown-tinted oil-based medium that has somewhat the same effect. In addition, the prints themselves are physically altered – or, as the gallery's press release says, borrowing a word from the lexicon of the antique dealer, "distressed" – with cuts, scrapes, and tears.

Archibald MacLeish once likened the artist's relationship to influence to a young boy's affinity for a neighbor's apple orchard, from which he might appropriate "what he has a taste for and can carry off." Clearly Gonzalez Palma has looked closely at the work of such contemporary practitioners as Joel-Peter Witkin and Mike and Doug Starn, and has "carried off" elements of their practice to feed his own appetites. But he is after different game. His handwork on the prints echoes the painstaking, reverential craft that goes into the making of icons and other sacred objects; the ochre tonalities evoke the fading evidence of 19th-century photographs, and the earth to which the body returns when the spirit leaves.

There is something in these images reminiscent of those portraits from the last century in which a photograph – often a tintype, sometimes a print on paper – was painted over; in some of those, all that's left of the photograph's trace of the real are the eyes, staring out from the fiction of the disguising pigment. Here one feels that slivers of history have been unearthed only to be reinterred. A fatalist at heart, Gonzalez Palma seems intent on creating a mythology for the purpose of laying it to rest; his photographing of living people of Mayan descent appears to be part of a process of mourning and burying their ancestors. Consequently, there is something sweet about these images, but also something infinitely sad – like your grandparents' request that you serve as pallbearer at their funerals.

Letter from: New York, No. 39

Several months ago, some publicity wonk at Warner Books – woops, make that WB prez Laurence J. Kirshbaum – issued a pronouncement that *Sex* by Madonna was one in a line of volumes designed to be "review-proof." Certainly, given the hoopla that all but smothered this latest venture by the Studied One, any review must seem an exercise in futility, especially if it attempts something so arcane and parochial as discourse about the photographic issues raised by this book of Steven Meisel's photographs.

It is a problem becoming increasingly pervasive, as celebrityhood infects mounting numbers of photographers. Apparently it's incestuously transmitted; photographers catch it from the celebrities they photograph. To some extent, that delimits the epidemic's spread, since only a small handful of photographers devote themselves to producing icons of those "well-known for being well-known" (Daniel Boorstin's useful definition of the celebrity). But those who do are taking up ever greater amounts of space – in the pages of books, on gallery and museum walls, in the news and culture pages of periodicals....

Which brings us to Madonna's *Sex*, and the work of Steven Meisel. Few books of photographs come to us bearing not only the photographer's name but a credit line for art direction – in this case, Fabien Baron. Taking a cue from my colleague in the pages of the *New York Observer*, "Accidental Auteurist" Andrew Sarris, I'm prone to propose that in this circumstance the photographer has been reduced to the equivalent of a cinematographer in commercial filmmaking, the true *auteur* here being the Studied One herself, orchestrating the efforts of Baron, editor Glenn O'Brien, and Meisel.

Assuming that Meisel was consciously picked for what his visual style would add to the mix, one would have to say that what the Studied One wanted was an adaptive *pasticheur* who, unlike Annie Leibovitz, would not bring his own ideas to the project but would be happy to get with the program.

That program was the creation of an image-text work that looks and feels like a Guess? Jeans/Calvin Klein fashion spread gone as close as soft-core can get to sexually explicit, a *haute-couture* glossy's appropriation of the intimate journal and scrapbook. The whole thing is, on initial encounter, oppressively self-conscious and styled, rather like those breathlessly confessional first-person ads that are now all the rage for selling everything from feminine hygiene spray to running shoes. (This is not surprising, given that editor O'Brien is the "creative director" of Barneys New York, a major men's clothing store – and reputedly the man beneath the undershorts behind the zipper on the Rolling Stones' *Sticky Fingers* album cover). Meisel's well-made photographs borrow liberally and shamelessly from everyone – André De Dienes, Helmut Newton, Herb Ritts, Cindy Sherman, Charles Gatewood, Bunny Yeager, Bruce of Hollywood; they jumble together everything from lyrical 1950s *plein-air* cheesecake to hard-core sex-club reportage.

There's black & white, monochrome, and full color included, as well as an occasional amusing reference to faded Ektachrome prints. They're sometimes presented one to a page, bled to the edges, and at other times collaged, montaged, combined and/or overlaid with text, and stapled together. In all cases they've been reproduced handsomely, on a matte-finish paper, spiral-bound between embossed and die-cut aluminum covers (which have a tendency to separate from the book after only a few perusals). The accompanying texts, presumably all by our *auteur*, are of four kinds: snippets of poesy and lyrics from her new album; first-person ruminations on her celebrated vagina and other sexual issues; explicit fantasies; and the correspondence of the bisexual "Mistress Dita" – an alter ego for the Studied One – with a lover named Johnny. (There's also a silly fotonovela, *Dita in The Chelsea Girl*, bound in at the back.)

In the end, Mistress Dita turns out to be homophobic, which strikes an odd note in what's otherwise a most libertine polemic. For that is what this book truly is: an endorsement of the polymorphous perverse in all of us, a

manifesto of sexual liberation. And for all of its calculated, mass-merchandized, publicity-hounded qualities, I think it's effective as such. If it is a project that's unimaginable without the mass media, Hollywood and Madison Avenue, it is also unimaginable without Doris Lessing and the women's movement. Through all the hype, puerility and narcissism, there's an intelligent awareness of the importance and value of sexuality, an acceptance of the body, and a fundamentally healthy candor and shamelessness radiating from both imagery and text that feels – dare I say it? – wholesome. It may not be your dish of tea, and it makes no major contribution to photography, but I suspect it will do no one any harm and may actually do the Studied One's legions of fans some good. And it looks like Kirshbaum was right; despite my having said this, the edition of 500,000 copies is reported to have sold out completely at $49.95. (There's a paperback reportedly in the offing, a year down the pike.)

Meanwhile, news reaches this desk that the true pioneer of this form and role model for this effort, Betty Page, long retired and now living somewhere in Florida, has decided to make a voice-only appearance on a major talk show ...

Letter from: New York, No. 40

Where is Africa? Carrie Mae Weems's current installation at P.P.O.W., "Sea Islands," asks that question – and suggests an answer at once unnerving and reassuring. For what this meditation on the Gullah culture of the black communities off the coasts of Georgia and South Carolina proposes is that African culture was not truly subsumed by the slave trade, but only transported and transplanted. Africa, Weems concludes – and not some imagined "Africa of the mind," but an Africa as real and tangible as enduring mythology and ancient tribal custom – is here, in the United States, among us all.

The show opens with rephotographed versions of what were essentially mug shots of captured members of the Gola tribe (whence "Gullah") of West Africa – daguerreotypes (from the collection of the Peabody Museum in Massachusetts) of a black man and woman, seen full-face and in profile. Weems has enlarged these images, eliminating their initial miniaturization of their subjects and restoring them to life-size. This does not mute the implacable stare of the camera; but it makes obvious these individuals' confrontation of the lens and the alien culture behind it, their obdurate returning of that look.

In the adjacent space, the walls bear a series of image-text pieces, while pedestals display a series of dinner plates whose "food" is textual. The wall pieces incorporate Weems's black & white images of the landscape, community structures (a store, a "praise house") and residences of the Gullah today with texts that recount fragments of Gullah history, folklore and tradition. The photographs, greatly enlarged from 2-1/4 inch negatives, are straightforward, formally conventional studies, reminiscent of Walker

Evans's scrutinies of the homes, shops and churches of the rural southeast; the texts are succinct, well-chosen and evocative. Particularly painful is "Ebo Island," the account of a group of Ibo tribesmen who, upon landing on Saint Simons Island, chose to walk *en masse* into the sea and drown rather than enter into slavery.

Embedded in the glaze of each plate are the words "I Went Looking for Africa," each time followed by a different "place" where the artist feels she located it: in the growls and plaintive wails of "Sonny Boy [Williamson]'s blues," in gumbo, in Gullah culture itself. If one thinks of evidence of one's heritage as a form of nourishment – a true "soul food" – then the appropriateness of the initially jarring dinner plates as vehicles for the tale of this search becomes obvious. "Sea Islands" is not anthropology, nor historianship, but a highly personal inquiry into the autobiographical resonances of the persistence of an indigenous culture even after its violent uprooting – an intractability that the kindly, patronizing white slaver imagined by Randy Newman in his extraordinary lullaby, "Sail Away," could never have conceived.

Letter from: New York, No. 43

New York being the stewpot that it is, I found it possible in one recent week to see the following:

The late Roman Vishniac's account of small-town Jewish life in Poland just before the Holocaust, on view at the Howard Greenberg Gallery and the International Center of Photography at Midtown;

Frederic Brenner's "Romanus Judaeus," a set of curious, unsettling panoramas of Italian Jews deployed throughout the historic monuments of Rome, also at Howard Greenberg;

"Assault on the Arts: Culture and Politics in Nazi Germany," a chilling study of fascist aesthetics, at the New York Public Library;

"Christian Boltanski: Books, Prints, Printed Matter, Ephemera," a survey installed by the artist himself, also at the NYPL;

And "Photography in Contemporary German Art, 1960 to the Present," at the Guggenheim Museum SoHo.

Meanwhile, I was reading and pondering Arthur Danto's review of the last-named exhibit in the March 29th issue of *The Nation*. This is an ambitious attempt to establish distinctions between "photography as art," presumably produced by photographers, and "photography in art," produced by artists Danto elects to name "photographists." Unfortunately, for all its striving, it is terminally flawed by failures that are uncharacteristic of Danto: sloppy thinking, unfamiliarity with the field of ideas, and a profound unawareness of key issues of craft.

It is uncommon to find, at this late date, anyone so naive as to believe that photography "replicate(s) the forms of reality" or "transfers appearances from the face of reality to a blank surface" – that is, anyone who still assumes, as André Bazin did so innocently fifty years ago, that photography of any kind is transcriptive rather than translative, indeed transformative, in its relation to whatever's before the lens. To define photographers simplistically as picture-makers concerned with generating, in Danto's words, "aestheticized work of the kind urged, for example, by Alfred Stieglitz," is to ignore – or be ignorant of – not only the complexity of Stieglitz's own thought but some five decades of subsequent photographic activity by people who called themselves photographers, including serious hermeneutic and exegetic inquiry. And to conflate photocollage (the gluing together of scraps of photographic images) with photomontage (the superimposition of one or more photographic images, in the negative or in the print) is to mix up two approaches to craft more radically different than, say, etching and woodcut, which one can hardly imagine Danto allowing himself to confuse.

The real function of his proposed distinction between "photographer" and "photographist" would seem to be the creation of a chasm between the two – a chasm which not only segregates the two but, implicitly, leaves "photographers" behind, endlessly retracing the footsteps of Stieglitz in the desperate hope of being called artists. That, in turn, eliminates the necessity of acquainting oneself with their work, and with the field of ideas from which it comes. Would it not seem reasonable to expect Danto, who's written at length about Cindy Sherman, to know and refer to the work of Les Krims, who began creating grotesque *tableaux vivants* in the mid-'60s, and under whom Sherman studied in Buffalo? Or the directorial work of Ralph Eugene Meatyard, whom Sherman herself has acknowledged as an influence?

Is Frederic Brenner, who deploys his subjects in groups throughout the amphitheaters, arcades and other ancient sites of Rome, poses them formally, describes them with a panoramic camera and interprets his negatives in small silver-gelatin prints, any more a photographer (or less a "photographist") than Thomas Ruff, who, as one can see in the Guggenheim-satellite exhibit, makes formal portraits in color of his fellow Düsseldorfers with a large-format camera and renders them in prints ten feet tall? When Gerhard

166 *Letter from*

Richter, represented in the same show, gathers found snapshots and mounts them in large clusters, is he more a "photographist" than the Russian photographer Boris Michailov, who's been doing the same thing for years?

In short, this photographer-photographist division does not seem to me to be at all useful. On the contrary, it's my belief – and the premise of this column as an ongoing project – that there's much more to learn from engaging the entire field of lens-based and lens-derived imagery than there is from amputating chunks of it because those chunks might contradict our assumptions or challenge our tidy definitions. There are fruitful comparisons to be drawn, shared thinking to be analyzed and multi-directional flows of influence to be traced between and among all those who engage thoughtfully with photography. Not that I'm expecting any unified-field theory to emerge immediately. But a discussion of the work of, say, Krzysztof Wodizcko – who projects accusatory photographs onto the sides of buildings – can only benefit from an awareness of the muck-raking lantern-slide shows staged by the 19th-century journalist Jacob Riis. The discourse around Alfredo Jaar's installation "1+1+1" would profit from analogy with the work of economist-turned-photographer Sebastião Salgado. The self-portraiture of Sherman solicits analogy not only with the *œuvres* of Meatyard and Krims but also with the work of the Photo-Secessionist Anne Brigman and the cheesecake photographer Bunny Yeager.

Which is to say that critics who choose to discuss photo-related work can no longer afford the embarrassment engendered by their ignorance of photography's history. Gary Garrels of the Walker Art Center in Minneapolis, the curator of "Photography in Contemporary German Art," mentions in passing the influence on some of the work he includes of the "New Subjectivity" movement in photography in 1950s Germany. Should not an awareness of its precedent, the "Neue Sachlichkeit" (New Objectivity) – and some discussion of the morphology that led to both – be expected also from those critics who choose to discuss this exhibit?

Speaking of which, as a survey of the photography-related work of two generations of Germans with international reputations, Garrels's selection is mostly predictable. Joseph Beuys, with his pictorialist-cum-Dadaist traces of his various art "actions," is presented as one of its seminal figures; the

husband-and-wife team of Bernd and Hilla Becher, with their straightfor-
ward taxonomic documentation of industrial structures, are the other. In
between are, in addition to those already mentioned, Anselm Kiefer, Sigmar
Polke, Astrid Klein, and a dozen more.

They are a grim and humorless lot, on the whole, but that is not the only
quality that keeps this exhibit from being, in Danto's words, "viewer-
friendly." Danto goes to great lengths to inform us that this is the kind of
art Hegel prophesized (or warned us about): an art that would help us in
"knowing, philosophically, what art is." It is an art, thus, that promises
gainful employ to philosophers, Danto among them. It is also an art that,
rather than testing theory in practice, takes theory as a prescription for
praxis. Unlike the "degenerate" art suppressed by the Nazis – the work of
John Heartfield or Kurt Tucholsky or Otto Dix or George Grosz, or, for
that matter, Bertolt Brecht, Kurt Weill or Thomas Mann – the meaning of
this work is not readily accessible to the average intelligent citizen. Decoding
it involves familiarizing oneself with the current excruciatingly jargonized
discourse, most of it written by people who, as a colleague put it, "aspire
to read as if translated from the German."

Beyond that, one must also be willing to immerse oneself in an appalling
swamp of rampant intentionalism, for this work guards its messages so
carefully that they are only made available via the explanations of its makers
or their exegetes. If art has, as many argue, taken the place of religion in
modern culture, then this art is decidedly Catholic rather than Protestant in
its rejection of the idea that the viewer should be able to stand before it and
come to terms with it without benefit of clergy.

It is, in short, profoundly authoritarian – and, like all authoritarianism,
terrified at heart. However one values their art, one can understand simply
from looking at, listening to, or reading their work what made Grosz and
Dix and Brecht *persona non grata* during Hitler's regime. Yet, though it's
put forward as an oppositional response to totalitarianism in general and
Nazism in particular, the work in this show seems unlikely to get anyone
blacklisted (at least if detached from its critical apparatus). It virtually radi-
ates the fear of blunt, plain speech, and – to the extent that it is, or claims
to be, political – avoids the obligation of direct, unequivocal critique. (As

someone said of a valedictory lecture by the Nazi educator and philosopher Martin Heidegger, you couldn't be sure whether you were supposed to re-read the pre-Socratics or join the S.A.)

Treated as a cross-section and seen sociologically, what's manifested most vividly here is a pernicious obscurantism and a rage for regimentation. The grid is the predominant structure, so recurrent that in itself it forms the show's most memorable visual pattern; the bulk of what's on view is neat, clean, obsessively ordered – as if fanatical repression of the unruly were a check on the totalitarian impulse, and not symptomatic of it. What it evokes, overall, is a stereotype of the Teutonic that was surely unintended by all concerned.

This show is in no direct way about fascism and the Holocaust; nor am I suggesting that it should be. At the same time, I don't believe that those subjects are ones to be avoided; as Günter Grass argued in 1990, "whoever thinks about Germany now and seeks answers for the German question must include Auschwitz in his thoughts." And I find it curious that – in the context of other work in town that tackles those issues head-on – they don't come up here in any detectable way. Resonant work addressing that history can be made, and has been. I think here of the Children's Memorial and the Room of Names at Yad Va'shem in Jerusalem, but also of Vishniac's documents, which he preserved unassisted for years as an archive, and of Christian Boltanski's elegiac "Gymnasium Chases" series, based on the 1931 graduation photograph of a Jewish high school in Vienna, a suite of prints that's on view at the Public Library. Vishniac wanted people to re-member the dead; Brenner encourages us to consider the living; and Boltanski has said, "What I want to do is make people cry."

What the "photographists" represented in this exhibit want to provoke with their work – if anything – is far from clear. To step into this exhibit is to encounter several post-war generations of German artists reluctant to let their work speak for itself. Is that because they believe it's inarticulate on its own, or because they're frightened of what it might say?

One Body One Soul © Miro Svolik 1990
Courtesy Stuart Levy Fine Art, New York

Letter from

Letter from: Prague/New York, No. 47

From Breda, in the Netherlands, where I left you last issue, I traveled on to Prague, a city that seems at once frozen in time and aboil in flux. Its present condition is emblematized by the debate over the proposed siting of a Frank Gehry office building – nicknamed "Fred and Ginger," for its abstracted resemblance (from one vantage point) to a classic pose by the Astaire-Rogers duo – on the banks of the Vltava. Mid-July, when I arrived, was the height of the tourist season (although I was told that it's now tourist season all year long), so this medieval town was transformed into . . . Kafkaville! From morning till night the city streets were full of tour groups trailing after guides with raised umbrellas or placards, and dotted with perplexed loners like myself desperately trying to correlate their accordion-fold printed street plans with the city's eccentric, determinedly ungeometric layout. Perhaps, along with the other newly devised souvenirs, the local merchants should hawk T-shirts bearing general-semanticist Count Alfred Korzybski's admonition, which could serve as the motto for the Republic right now: The map is not the territory . . .

This visit to the Czech Republic, my first, was made as a guest lecturer for the second summer workshop program of the Prague House of Photography, a new non-profit organization initiated by a consortium of more than sixty Czech and Slovak photographers, art historians and critics. Housed in a building at the end of Husova Street, in the heart of the oldest section of the city, the PHP occupies a ground-floor warren of low-ceilinged, white-painted, well-lit rooms ideal for showing small-scale work. Here, in addition to maintaining a regular exhibition schedule, a sampling of members'

prints is kept available for reference and purchase – along with an extensive selection of books and magazines on Czech and Slovak photography, plus posters, postcards and such.

On view at the time of my visit was "The Names of PHP," a group show by the collective's membership. Its diversity was typical of Czechoslovakian photography past and present; more even than Hungary (which gave us Brassai, Kertesz, the Capas, Lucien Aigner, and so many more), this country has produced notable figures in all varieties of photographic image-making. This show consisted of approximately 100 prints representing 43 people – samples of work, that is, but not enough to permit assessment unless one already knew the larger bodies of imagery from which they were excerpted.

For instance, I'd previously encountered the abstractions of Stepan Gryger, and the directorial work of Pavel Banka, Tono Stano, Miro Svolik, Kamil Varga, Vasil Stanko, Jan Saudek and Rudo Prekop – a number of whom I've discussed in these pages – and so had reference points for these recent efforts. New to me, however, were Jan Pohribny's large color prints of images describing his interventions in the physical landscape; Zdenek Lhotak's monochrome scrutiny of his own feet; the wry humor of Peter Zupnik's "The cat that wanted to be a tiger" and several manually altered images; Jiri Hanke's shrewd, finely-seen small-camera images from a series titled "Views from the window of my flat"; Gabriela Capkova's humorous image-text pieces addressing men with bicycles; Robert Silverio's photocollages; Ales Kunes's two assemblages incorporating exposed and developed large-format negatives; and Vladimir Kozlik's Cibachrome "Seasons of the Year" and other conceptual pieces. All whetted my appetite for more than was on the walls, and their supplements in the print files.

The summer program's offerings, which my schedule didn't permit me to observe, included lectures by curator Antonin Dufek and historian/critic/editor Daniela Mrazkova, and workshops with a diverse cross-section of notable contemporary figures: Miro Svolik, Stepan Gryger, Pavel Banka, Tono Stano, Viktor Kolar, Jan Pohribny and others. The only non-Czech/Slovak among them was Suzanne E. Pastor, a transplanted Chicagoan who's one of the PHP's co-founders and serves as its director. Their publicity for this program was haphazard, to put it kindly; when it comes to business

Letter from

matters, I was told, everything there runs at about 20 percent of US speed, if you're lucky. Still, twenty or so participants showed up from places as far-flung as Berlin and New Orleans, the faculty was enthusiastic, and from all reports the program came off to everyone's satisfaction. Next year's workshop program is already in the planning stage

Aside from giving two lectures, one for the PHP and another for the students at FAMU, the film and photography school, I spent my week wandering the city: sightseeing, sitting in pubs and cafés, browsing the vendors on the Karlovy Bridge, listening to Renaissance music at some of the myriad concerts, going to the theater, and nosing out what was being offered in the way of photography. It added up to an astonishingly rich and bewilderingly diverse cultural stew, whose ingredients included:

Soaking up the exhibit "Art for All the Senses: Interwar Avant-Garde in Czechoslovakia," a stunning survey at the Wallenstein Riding School. This reprise of a show that originated at the Museum of Modern Art in Valencia, Spain, though cut down by half from that version, still offered 200 original works – including rarely-seen material by photographers of the caliber of Jaroslav Rossler, Joseph Sudek, and Jaromir Funke, and lesser-known but no less important photocollagists such as Karel Teige, Jindrich Styrsky, and Toyen (who now has a Czech rock band named after her).

Chancing on a concurrent, complementary show, "Les Champs Magnetiques," addressing the relation between André Breton and the Czech surrealist movement in the years 1934–38, sponsored by the Institut Français de Prague and the Museum of Czech Literature – books, posters, broadsides, correspondence, prints, ephemera from this most fertile of periods in European cultural life, when the Prague-Paris axis was internationally germinal.

Watching a double bill of two of ex-president Vaclav Havel's one-act plays involving Vanek, his alter ego, including his classic "Audience," in a fine production put on by a British company.

Coming across an amiable show of vintage prints of mostly seconddrawer material by Sudek, Frantisek Drtikol and D. J. Ruzicka at the Dobra

Gallery on Kostezna, one of the few in the city specializing in photogra-
phy – and, around the corner on Parizska, browsing the collection of old
cameras, photo magazines and photos at Fotogalerie, a processing shop.
Snapping up a mint-condition copy of one of Sudek's classic volumes on
Prague in a used-book store.

Seeing my first "black-light theater," a uniquely Czech form of entertainment
that combines dance, mime, theater, and inventive visual play involving
ingenious special effects made possible by a UV lighting style first popu-
larized here in the '60s. The influence of this form of image-making on
the directorial photography that began to emerge in Czechoslovakia in the
early 1980s – the work of Varga, Prekop and Banka, for example – mer-
its investigation.

Having an espresso in solitude on a rainy afternoon at Manes, the local
artists'-union meeting house.

Spending a chunk of my modest honorarium on inexpensively priced mono-
graphs on Sudek, Jan Saudek, the collagist Jiři Kolar and a number of
younger figures.

Spending another chunk on a dozen surrealist etchings and engravings by
some of the young graphic artists who hawk their work on the Karlovy
Bridge. (At $3–5 per print, how can you go wrong?)

Passing a delirious afternoon playing guitar and singing the blues in Jan
Saudek's hermetic studio.

Throughout all that, I could not escape the feeling that this country is un-
dergoing yet another occupation, more insidious than the years under
Soviet military domination because now the occupying forces are not tanks
and guns and soldiers but Mad. Ave.-style commercials, foreign currencies,
and the tourist trade. A Velvet Occupation, if you will. That may be prefer-
able to military rule, in terms of the dynamics of everyday life, but perhaps
poses an even greater long-term threat to culture.

With a pizza shop on Karlovy Street, Iggy Pop concerts in the stadium,
the entire exteriors of streetcars sold to advertisers and a massive poster
campaign equating advertising with free speech all around town, and
X-Men comic books at the kiosks (not to mention an imminent Gehry-

on-the-Vltava), can an overnight epidemic of mall culture not be far behind? Zdenek Primus, Suzanne Pastor's husband and a specialist in rare 20th-century books, tells me, "Underneath all this, it's still Czechoslovakia." I want very much to believe that he's right. My fear is that Prague will turn into a *nouveau*-capitalist theme park before our very eyes. But a country that brought off a bloodless revolution, elected a first-rate native playwright to its presidency, and named Frank Zappa as its cultural ambassador clearly has sleeves full of aces, so my plan is to have a becherovka with a beer back, sit tight, and watch.

Acknowledgements

As with all my work, this book, and the much larger body of material from which it's drawn, has its debts to pay.

To begin with, I want to thank Pat Quarles and John Petit of New York University's Alternative Media Center, and Eddie Aponte of that university's SEHNAP Computer Microlab, for first throwing me into the cold water of word processing and then lending me their sympathetic hands as I learned to swim. That beneficial transformation of my working life infuses this book on all levels.

Several editors at different publications have supported this project in various ways. Suzanne Mantell, Lauren Ramsby, and Susan Morrison at the *New York Observer* and Bill Mindlin at *Photography in New York* supplied the platform from which much of it sprang. Henry Brimmer of *Photo Metro* conceived, and made space in his pages for, the "Letter from" column into which it all got folded. Under similar rubrics, Pierre Borhan and Alain d'Hooghe of *Clichés* in Belgium, Walter Keller of *der Alltag* in Switzerland, Jose M. Diaz-Maroto and Myriam de Liniers of *Visuel* in Spain, and Chris Dickie of the *British Journal of Photography* all provided shorter-lived but much-valued vehicles for various installments of the column, in several languages, during the period covered by this selection. And Andreas Müller-Pohle of *European Photography* in Germany – who continues to sponsor my first and longest-running forum in Europe – not only published some of this material but also made the connection that sparked the publication of this volume.

The basic editing of this book took place during a three-month residency as Guest Scholar at the J. Paul Getty Museum in California in the fall of

1993. The clear, unencumbered psychic space provided by that opportunity; the support of John Walsh, Director of the Museum, and Weston Naef, Director of its Department of Photographs; and the unfailingly cheerful assistance provided by the staff of the Getty Museum and Center, made the task a pleasure. My thanks to them all.

That first edit was further refined during the course of a residency as a Fulbright Senior Scholar in Sweden, at the University of Gothenburg's Fotohogskolan. I'm grateful for the sponsorship of the Fulbright Commission and the Fotohogskolan, which proved vital to my pursuit of several long-term projects, this book among them.

The rough cut that resulted benefitted enormously from the thoughtful attention of two of my closest readers and severest critics: artist, art historian and independent curator Colleen Thornton, currently based in Copenhagen, Denmark, and photographer/curator/arts administrator Kathy Vargas of the Guadalupe Cultural Arts Center in San Antonio, Texas. Their help in narrowing the remaining heap down to its core material was invaluable.

Bill Jay is one of the few people in the field who understand the difference between appreciation and support. His determination to speak his own mind, and the clarity of his thought and prose, has long made him a valued colleague, while his public and private encouragement of my own efforts has been energizing. I'm pleased that he agreed to introduce this book to its readers.

Finally, of course, my thanks to Chris Pichler of Nazraeli Press, whose enthusiasm, intelligence, patience and professionalism have made this project a provocation and a joy from start to finish.

A.D.C.

About the Author

Media commentator and educator A. D. Coleman lectures, teaches and publishes widely both in the United States and abroad. He has been described by the *New York Times* as "a brilliant writer, critic, and observer of the photography scene"; the *Village Voice* called him "photography's metaphysician."

Since 1967, his "controversial, pungent, and influential" essays have provoked and delighted a national (and, increasingly, international) readership. With more than 170 columns in the *Village Voice*; 120 articles in the *New York Times*; features in such diverse publications as the *SoHo News*, *l'Officiel USA*, *New York*, *Art in America*, and the *Boston Phoenix*; introductions to several dozen books; and appearances on NPR, PBS, CBS's "Night Watch," and the BBC, he has demonstrated an ability to engage the attention of the general public. At the same time, the regular presentation of his articles in specialized journals – *Artforum*, *Et cetera: A Review of General Semantics*, *Impact of Science on Society* (France), *Luna Cornea* (Mexico), *Fotologia* (Italy), *The Journal of Mass Media Ethics*, and *The Structurist* (Canada) among them – attests to the scholarly community's regard for his work. A member of PEN American Center, The Authors Guild, the National Writers Union and the American Society of Journalists and Authors, Coleman also served for years as Executive Vice-President and Membership Chair of AICA USA, a chapter of the international association of critics of art.

He received the first Art Critic's Fellowship ever awarded in photography by the National Endowment for the Arts in 1976, a Logan Grant in Sup-

port of New Writing on Photography in 1990, and a major Hasselblad Foundation Grant in 1991. He was a J. Paul Getty Museum Guest Scholar in 1993 and a Fulbright Senior Scholar in Sweden in 1994. His published books include *The Grotesque in Photography* (1977) and *Light Readings* (1979). A second, expanded edition of the latter will appear in 1996, accompanied by a new collection of essays, *Depth of Field.*

Presently Coleman serves as the photography critic for the *New York Observer*; his columns appear regularly in *Camera & Darkroom*, *Photo Metro*, *Photography in New York*, *European Photography* (Germany) and *Juliet Art Magazine* (Italy). In addition to photography, art, mass media, and new communication technologies, Coleman's subjects have included a wide range – from music, books, theater, and education to politics and cooking. His work, which has been translated into seventeen languages and published in 24 countries, is represented by Image/World Syndication Services, POB 040078, Staten Island, New York 10304-0002 USA, phone/fax 718-447-3091.

Photo Credit: f. stop fitzgerald

Index

Author's Dedication:
This book is dedicated to the spirit of my
maternal grandfather, James Candlish Allan
(August 23, 1877 – November 25, 1956),
of Elkins, West Virginia; born in Edinburgh,
Scotland, freethinker, carpenter, housepainter
and farmer – my first memory of love.

Front Cover: *Untitled*, Nicolo Vuco 1930
Museum of Applied Arts, Belgrade

Order Address: Nazraeli Press
Siegfriedstr. 17 Rgb
D-80803 Munich, Germany

In the US: Nazraeli Press
Fulfillment Services
1955 West Grant Road, Suite 230
Tucson, AZ 85745

Printed and bound in Germany
ISBN 3-923922-26-4